LEARN TO DRAW
THE FIGURE

JAMES HORTON

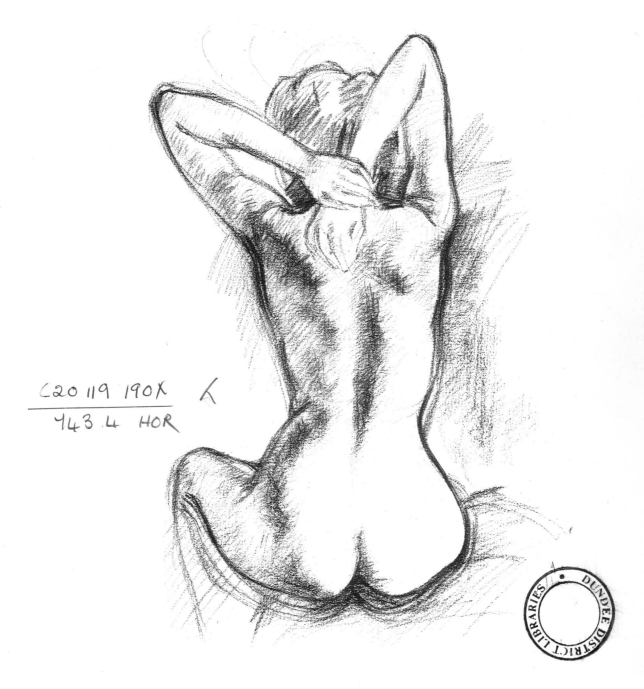

COLLINS

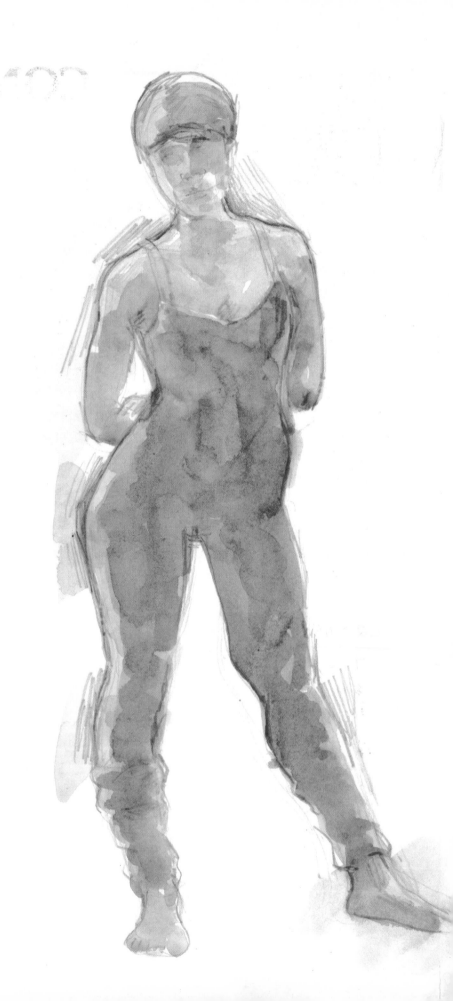

First published in 1985
Wm Collins Sons & Co Ltd
London · Glasgow · Sydney
Auckland · Toronto · Johannesburg

© James Horton, 1985

Designer: Caroline Hill
Photography: Peter Lofts

Filmset by Chambers Wallace, London
Colour reproduction by York House Graphics
Printed and bound in Italy
by New Interlitho, Milan

ISBN 0 00 411915 0

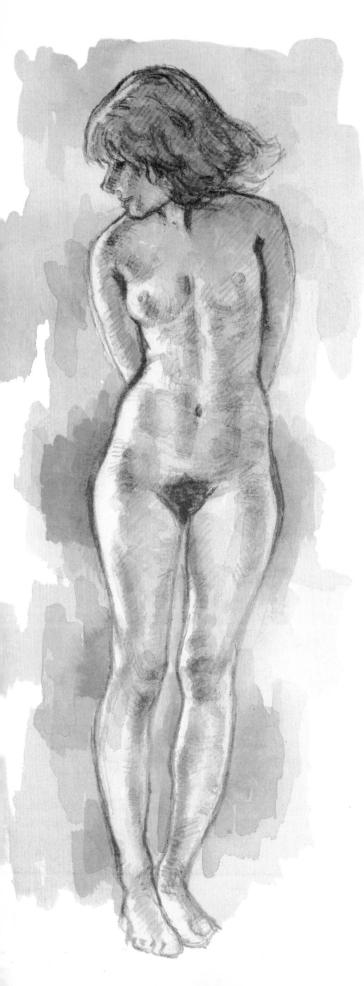

CONTENTS

PORTRAIT OF AN ARTIST
JAMES HORTON

Fig. 1 James Horton working in his studio in Cambridge

James Horton was born in London where all of his education took place. His father, George Horton, was for many years a stonemason. Apart from carving marble and, more often, granite, he possessed a keen interest in painting and drawing, which sparked off in James the original desire to be an artist. The first serious considerations of making art a career came in his early teens, and at sixteen he felt confident enough to leave school in favour of going straight to art school.

For two years he studied drawing and painting at the Sir John Cass School of Art under Vivian Pitchforth and Percy Horton, the latter forming the strongest influence on his art and character. It was Percy Horton's integrity, love and understanding of great drawings, imparted through careful and enthusiastic teaching, that has been the backbone of James Horton's art since those early days.

On leaving the Cass School of Art he went on to study at City & Guilds School of Art for four years where he found a very sympathetic environment. It was a small art school which favoured working from life and figurative art in general. During this period James Horton also spent a good deal of time working upon figurative sculpture and before going on to the Royal College of Art for three years he was awarded a scholarship to Florence to study the Renaissance painters and sculptors.

Whilst at the RCA James Horton's work was included in the Young Contemporaries exhibition and he was a prizewinner in the BEA (British European Airways) Art Awards held at the Institute of Contemporary Art in the Mall, London. Since leaving the Royal College he has exhibited widely in Britain and abroad, including at the Royal Academy summer

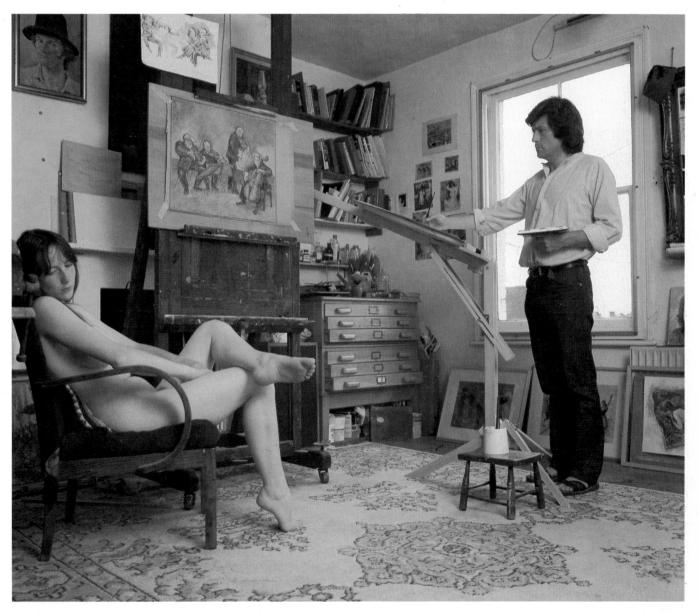

Fig. 2 James Horton working from a model in his studio

shows and the Royal Portrait Society. He has staged six one-man shows which have been held in major capitals such as London, Stockholm and Dublin. In 1980 he was elected to the Royal Society of British Artists where each year he exhibits at least one large canvas as well as several smaller ones.

James Horton's paintings vary in size enormously from the small, freshly painted landscapes or figure studies always made from life, to the large figurative subjects which take many months to plan and execute.

As a writer he has published articles regularly since 1978 for *The Artist* magazine. This in turn led to him being invited to participate as one of the artist advisers on methods and materials at the hugely successful 'Paint & Painting' exhibition staged by Winsor & Newton in conjunction with the Tate Gallery in 1982.

As well as drawing and painting, the other great love in James Horton's life is music. As a classical guitarist he has both taught and given performances, the most recent being as part of the Cambridge Festival in 1982. Like many other artists he feels a great affinity with music, and when time permits enjoys spending many hours practising in order to improve his technique and repertoire.

Perhaps acknowledging an early debt to the teaching of Percy Horton, James Horton is now a known and respected teacher of art, finding inspiration for his own work from his students. He lives in Cambridge, which he finds a stimulating centre, and is a part-time lecturer at the Cambridge College of Arts and Technology. He is also a part-time lecturer at the Sir John Cass School of Art and visiting lecturer to the Mary Ward Centre in London.

WHAT EQUIPMENT DO YOU NEED?

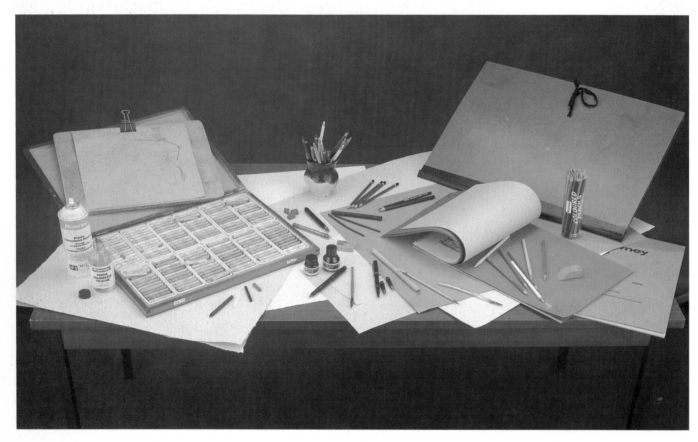

Fig. 3 Equipment for drawing with pastels, chalks, pencil, charcoal, coloured pencils, pen and ink, with key

a	bulldog clip	**j**	charcoal pencil		coloured Ingres
aa	small drawing board	**k**	general purpose		papers
b	box of Artist's Soft		pencil	**s**	eraser
	Pastels	**l**	process chalk holder	**t**	sketchbook
c	aerosol fixative	**m**	natural red chalk	**u**	quill pen
d	spray		with holder	**v**	reed pens
e	spray fixative	**n**	charcoal sticks	**w**	Osmiroid pen with
f	conté process chalks	**o**	putty rubber		detachable nibs
g	assorted papers	**p**	portfolio	**x**	dip pen
h	pastel pencils	**q**	coloured pencils	**y**	Rotring drawing pen
i	graphite pencils	**r**	pad of Fabriano	**z**	drawing inks

The basic requirements for making a drawing are quite simple and need only be a pencil and a sheet of paper. However, this is a rather limiting combination and sooner or later most people want to investigate and experiment with different types of media.

It might seem, from looking at **figs. 3 and 4**, that an enormous amount of equipment is required, but although some of this is basic and necessary to begin work, by no means does anyone learning to draw need all that is illustrated here straightaway. It has taken me some time to accumulate this equipment, which I use continuously in my work. To start with, the best thing to do might be to invest in the medium you find most appealing.

The question of quality is always difficult because it invariably relates to finance. As a professional artist, one should always use the best-quality equipment available, but it is really up to each individual to acquire the materials he or she can afford. For beginners usually the cheapest range available is adequate until some headway is made. Most paints (oil, acrylic and watercolour) come in two types:

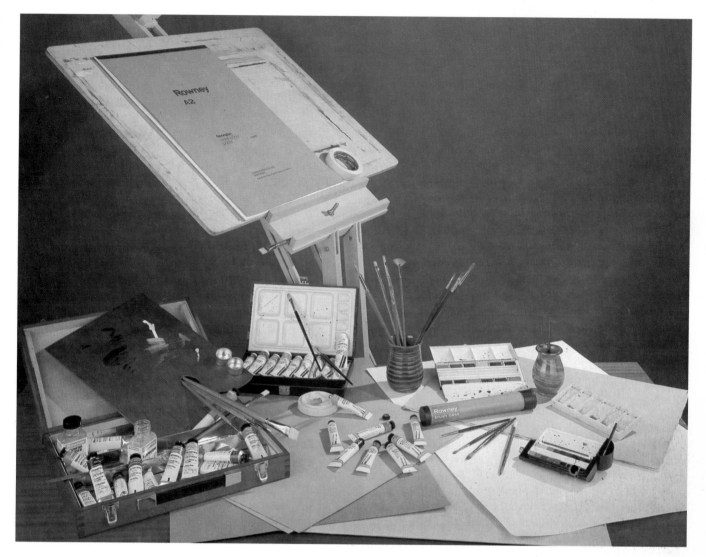

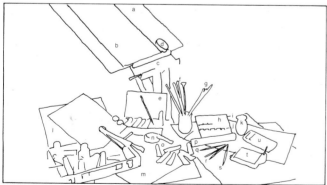

Fig. 4 Equipment for drawing with acrylic, watercolour, oil and gouache, with key

a A1 drawing board
b A2 watercolour pad
c Norwich radial easel
d masking tape
e acrylic paint box
f nylon brushes
g sable brushes
h studio watercolour box
i heavy watercolour paper

j hand-made watercolour paper
k water pot
l basic oil painting set
m selection of coloured papers
n china paint well
o gouache paints
p brush case
q best-quality sable

watercolour brush
r cheaper sable watercolour brushes
s nylon watercolour brush
t portable watercolour box incorporating water container
u large china paint well

Student quality, which has additives to make the colour go further and which is not as permanent as better-quality paint; and Artist quality, which in most cases is made with the highest-quality raw materials. This, of course, is reflected in the price. There is also a difference in the handling quality of the various grades of materials. Sable brushes perform better than synthetic; Artist quality colours are stronger than Student quality ones; and cheap paper will yellow and go brittle. It may take some time to build up to professional-quality materials, but ultimately every serious student should aim to achieve this.

One of the most basic pieces of equipment is an easel. It is possible to manage without one by propping a sketchbook or board on your knees, but anything larger than half imperial will be too cumbersome. The easel illustrated in **fig. 4** is sturdy, will take a very large drawing board and can be tilted back when watercolour paints are used.

It's a good idea to have two watercolour boxes. The small one illustrated is designed to slip in a pocket and has a water pot attached, which makes it convenient

for carrying around. I usually have mine in my pocket whether I expect to be working or not. The bigger box is for more involved work and is suitable for mixing larger washes in conjunction with the china paint wells. You can choose your own colours to fill an empty box, but for general purposes the ready-fitted versions contain a perfectly adequate selection for beginners.

Brushes for watercolour need not be expensive. Sable brushes are the best but they are not cheap. However, since the introduction of brushes made of better-quality synthetic imitations of the sable fibre, such as the Daler brush, there are now excellent alternatives available which are used by professionals and amateurs alike. If you choose sable, one medium-to large-size good-quality brush will suffice for most purposes, but if this is not within your price range, three synthetic brushes, sizes 2, 6 and 11, would be perfectly adequate. Nylon brushes seem to work well with gouache and acrylic paints, and often the longer-handled versions are preferable.

Care of brushes is essential, regardless of price. Never push down hard on the brush when rinsing in a water pot; this damages the hairs. Never let acrylic and oil paint dry on the brush, although watercolour and gouache are easily removed by soaking. A brush case is a good way of protecting your valued brushes.

The oil paint box illustrated in **fig. 4** is a standard set which includes brushes, a palette and a basic range of colours. You can buy oils separately but a ready-put-together box such as this one would be ideal. You will also need a palette to mix upon, some turpentine and linseed oil to mix with the paint, and a palette knife for removing unwanted paint from either the palette or the painting surface.

As with other media, pastels come in a range of standard colours, but unlike other media these are then graded into between six and eight tints. This is because pastels do not mix like paints and to achieve precise colours a greater range is necessary (see **fig. 3**). Smaller sets, sometimes with groups of colours put together by the manufacturer and suitable for portraits, figures or landscape, are also available. Pastel pencils are fun to use but do not have the covering power of ordinary pastels, nor are they made in such a large range of colours.

Like pastels, coloured pencils cannot be mixed in the same way as paints. However, the type of drawings made with these pencils (see **figs. 28-33**) usually do not aim at the same effect as that achieved with pastels or paints. A set of twenty-four coloured pencils (**fig. 3**) is sufficient.

The term 'pen and ink' covers an almost inexhaustible range if one includes the more commercial pens like biros and felt tips (see page 37). A technical drawing pen and Osmiroid Fountain Pen are very useful for carrying around in a top pocket or bag, but the traditional dip pens, such as the quill, reed and steel nib pen, need to be used with open bottles of ink.

There are many different types of chalk available, all of which are processed in some way except the natural red-earth *sanguine*. This possesses a lovely feel, but processed chalk has its own qualities, such as flat edges which are useful for creating certain effects. It also comes in different grades. As far as I know, *sanguine* is no longer available in Britain, but it can be obtained in Italy.

To erase part of any chalk, charcoal or pastel drawing, a putty rubber will be needed. This is a soft, pliable piece of rubber which can be kneaded into any shape, and rather than rubbing out, the technique is to lift off by dabbing gently. For pencils use an ordinary eraser. Fixative can be obtained in aerosol form or a bottle with a spray diffuser. The latter is useful in case you ever experiment with making up your own fixative from recipes.

The paper shown in these photographs ranges from cartridge to watercolour and is of course only a small selection of what is available. Roughly speaking, each medium has a paper to which it is probably best suited, although there are no hard and fast rules. The choice of paper depends very much on personal preference.

Pastel works best on coloured papers – Fabriano Ingres is particularly suitable – so that dark and, more importantly, light colours can be seen easily. This is also true of oil, acrylic and gouache paints. Coloured papers such as Whatman and Fabriano are suitable for these paints. For oil paint the paper must be sized to prevent the oil soaking into it. It is always a good idea to stretch the paper first by soaking it for about five minutes, laying it flat upon a board and taping it down with gumstrip, which needs water to activate the glue. This cannot be done with self-adhesive tape. As the paper dries, it contracts and any wrinkles will pull tight and disappear. This procedure also applies to all the watercolour papers, although often with the heavier grades (from 90 lb upwards) the weight of the paper is sufficient to keep it flat.

Chalks in combination with white can also be used on coloured papers. Ink works best on better-quality cartridge paper, which is fairly smooth, and coloured pencils are probably best used on white or cream papers. Ordinary pencil can be used on any paper provided it is not too dark. Not essential but useful is a portfolio for either keeping new paper in or storing drawings.

One of the great values of learning to draw is to understand the medium being used. Once familiarity with it is gained, along with the improvement of your objective faculties, it is then a good time to explore another medium and a new way of expressing ideas.

POSING THE MODEL

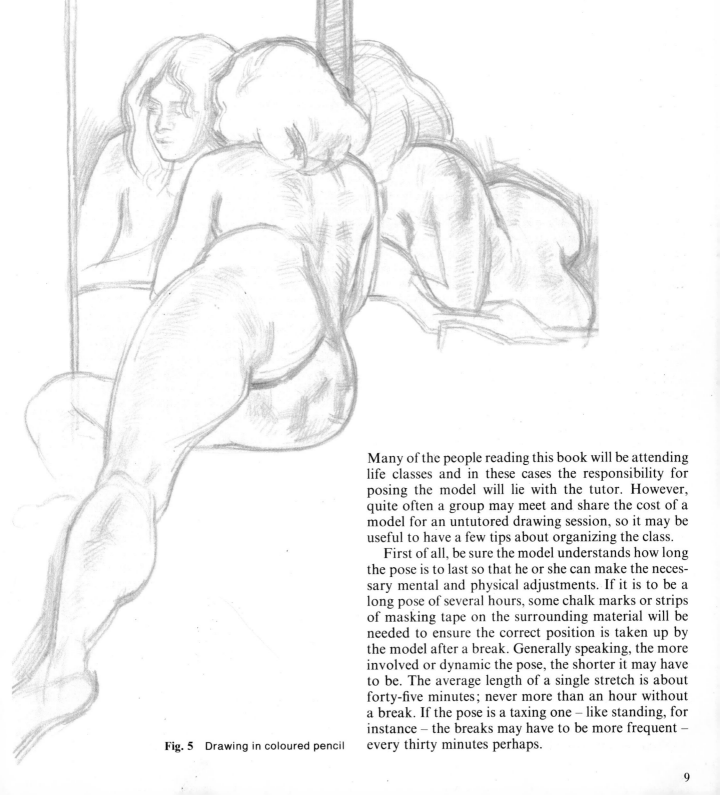

Fig. 5 Drawing in coloured pencil

Many of the people reading this book will be attending life classes and in these cases the responsibility for posing the model will lie with the tutor. However, quite often a group may meet and share the cost of a model for an untutored drawing session, so it may be useful to have a few tips about organizing the class.

First of all, be sure the model understands how long the pose is to last so that he or she can make the necessary mental and physical adjustments. If it is to be a long pose of several hours, some chalk marks or strips of masking tape on the surrounding material will be needed to ensure the correct position is taken up by the model after a break. Generally speaking, the more involved or dynamic the pose, the shorter it may have to be. The average length of a single stretch is about forty-five minutes; never more than an hour without a break. If the pose is a taxing one – like standing, for instance – the breaks may have to be more frequent – every thirty minutes perhaps.

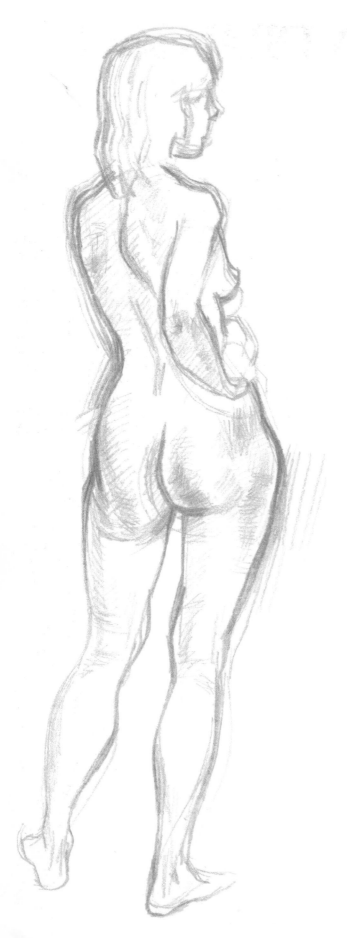

A word of caution about standing poses. If a model says that he or she is becoming uncomfortable, stop work immediately and let the model rest. I have known models to be perfectly all right one minute and to faint the next.

If possible, a number of props such as a studio couch, stool, or anything which will support the figure in a variety of positions is helpful. A selection of coloured drapes can be useful to have around, too, either to make the pose more comfortable for the model or simply to provide some immediate background.

Earlier I mentioned the necessity for the model to make the mental and physical adjustments for each pose. Once the model is settled it is the artist's turn to make the same adjustments. If it is possible to do so, walk around the model and size up the different possibilities that each viewpoint gives. Some poses may be quite dull from one position but very exciting from another, and this, of course, will have a lot to do with the lighting. Never accept what happens to be the pose from your immediate location. It is important to be selective about this so that your drawing begins with a good amount of enthusiasm and not a matter-of-fact acceptance.

Consider also the effects of different eye levels. If the model is posed on the floor and the artist is standing at an easel, some very interesting downward views will result. Conversely, if the model is posed on a throne or raised platform, as is often the case in an art school life room, everything will be much closer to the eye level, especially if you sit down.

If the room that you are drawing in is small or crowded, it may not be possible to choose a more advantageous position and in that case the discipline of coping with a pose over which there is no control can be a stimulating experience.

The length of the pose may vary from session to session, but most classes or groups will want some short poses at some stage (by short, I mean anything from one to ten minutes). This can be rather disconcerting to some people, particularly the inexperienced or less confident, because of the speed in drawing required. However, these shorter poses are an essential part of learning to draw, and later in the book I will discuss the value of drawing from moving models such as dancers and people in workout classes, which also demands swift execution.

The main point to remember when drawing rapidly is that you are not after a finished drawing but an image that captures the essence of the pose. One advantage of short poses, of course, is that you can ask your model to adopt more dynamic positions which would be impossible to hold for long periods.

Fig. 6 Drawing in coloured pencil

STARTING A DRAWING

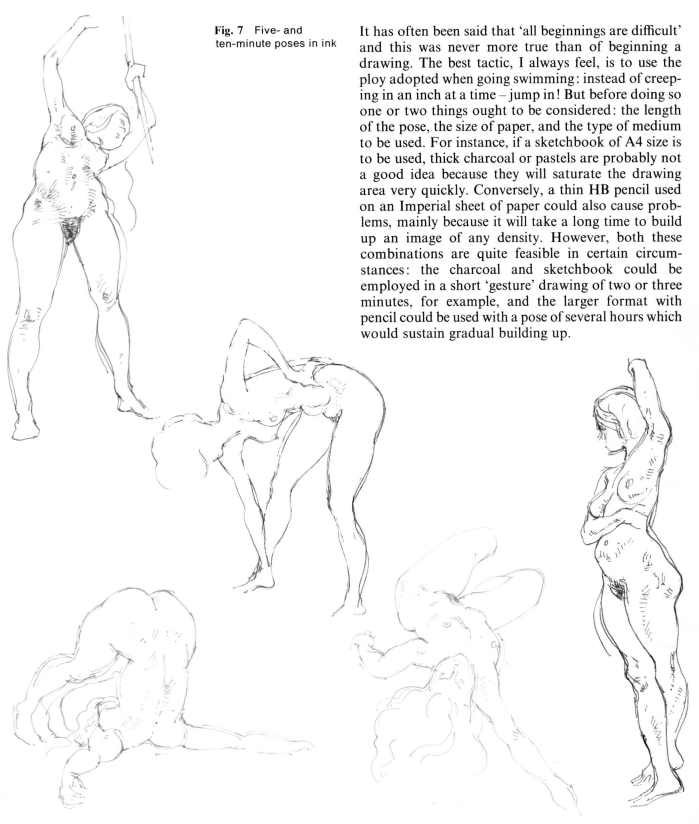

Fig. 7 Five- and ten-minute poses in ink

It has often been said that 'all beginnings are difficult' and this was never more true than of beginning a drawing. The best tactic, I always feel, is to use the ploy adopted when going swimming: instead of creeping in an inch at a time – jump in! But before doing so one or two things ought to be considered: the length of the pose, the size of paper, and the type of medium to be used. For instance, if a sketchbook of A4 size is to be used, thick charcoal or pastels are probably not a good idea because they will saturate the drawing area very quickly. Conversely, a thin HB pencil used on an Imperial sheet of paper could also cause problems, mainly because it will take a long time to build up an image of any density. However, both these combinations are quite feasible in certain circumstances: the charcoal and sketchbook could be employed in a short 'gesture' drawing of two or three minutes, for example, and the larger format with pencil could be used with a pose of several hours which would sustain gradual building up.

One other aspect that ought to be considered before beginning is the image size, by which I mean literally the size of your drawing upon the paper. In order to understand the sort of rhythms that occur in a pose it is essential to draw the whole figure, so work out roughly in advance how much of the paper the drawing will occupy and be sure it is enough to include all of the model.

One way of getting a life drawing session started and at the same time overcoming the initial tentative beginnings is to draw a series of five- and ten-minute poses such as in **fig. 7**. This has the advantage of forcing you to make marks within a limited time scale, and after a while the adrenaline begins to flow which helps to overcome inhibitions about the results.

The full value of drawing short poses can only be realized if the *whole* pose is drawn. To spend ten minutes on developing just a head and shoulders, for example, means that the rate of drawing is the same as for a longer pose. The discipline of a short pose is to force the artist to make a statement, complete in itself, about the pose given within the allotted time. This way your thinking process has to speed up to deal with the urgency of the situation.

Measuring

This brings me on to measuring, which is essential at some stage in a drawing in order to keep a check on proportions. However, it is very easy to let measuring become a method of construction rather than of checking. I always do a substantial amount of drawing before I measure so that I can check the proportions of one part against another. Certainly a drawing can be made by measuring before each statement and gradually building up a tight network of inter-related marks, but the drawbacks are that it rather inhibits the 'jumping in' approach and, ironically, it is also easy to become inaccurate by making a slight miscalculation which is magnified each time a measurement is made. It is rather better to trust your eye a little more and to measure the larger parts of the figure, such as the distance from the pit of the neck to the pubic arch and the pubic arch to the feet. To try and measure how many times the head goes into the body, for example, would almost certainly result in inaccuracy because of the many times the pencil (used for measuring) is moved.

Figs. 8, 10 and 11 show the sort of distances on a figure that are useful to measure and then compare to other parts of the body. For instance, in **fig. 11** the distances from head to shoulder and shoulder to waist are exactly the same. The same distance divided into the length from the waist to the heel goes about four times. **Figs. 8 and 10** show areas of the body roughly divided, at fairly obvious points, for comparison.

There is one other aid which can be used while drawing and that is a plumb line. This is exactly the same as the type that builders use on site and it serves the same purpose – to ascertain a true vertical. A plumb line is easily made by attaching a weight to a piece of string about two or three feet long. When held against the figure it will show which parts of the body correspond to the same vertical line. It is particularly useful in standing poses.

Obtaining a true horizontal can be more of a problem. It is easiest if you are sitting on an art school-type 'donkey' – a low wooden bench which you sit astride and which has a support at the front for leaning your board against. By lowering your eye to the top edge of your board you will get a true horizontal. Otherwise hold up a pencil and ensure it is as horizontal as possible.

Figs. 9 and 12 show the use of verticals and horizontals when measuring. In **fig. 9** the knee lines up with the armpit, although in space it is a lot further away. The horizontals in **fig. 12** are very useful for making sure that the figure occupies the correct place in space and perspective. It is very easy to misjudge the relation of the feet to the head in reclining poses unless this sort of check is made.

Proportion

One hears the word proportion quite a lot within the context of figure drawing. Generally speaking, it refers to the way in which various parts of the body, often the limbs, relate to each other. Proportions differ quite considerably between individuals and often the key to achieving something of the character of the model will be in getting the proportions right. Sometimes measuring will help, but often it is better to try to use your eye to determine the rough proportional characteristics. This is one very good reason for making sure the whole figure is included when drawing standing models, because without their length it is impossible to know their width! Quite often I have seen drawings in the life room which in themselves are of a passable standard but when compared to the model do not have the right proportional characteristics.

Exercise Using a plumb line and a horizontal make a drawing from a three-hour pose. Plot carefully the parts of the figure which correspond to the verticals and horizontals. For the purposes of this exercise draw in all the construction lines so that when the drawing is complete it is possible to see clearly the parts of the figure which link up.

In addition, make some relative measurements as illustrated (**figs. 8, 10 and 11**) and as before include the construction lines.

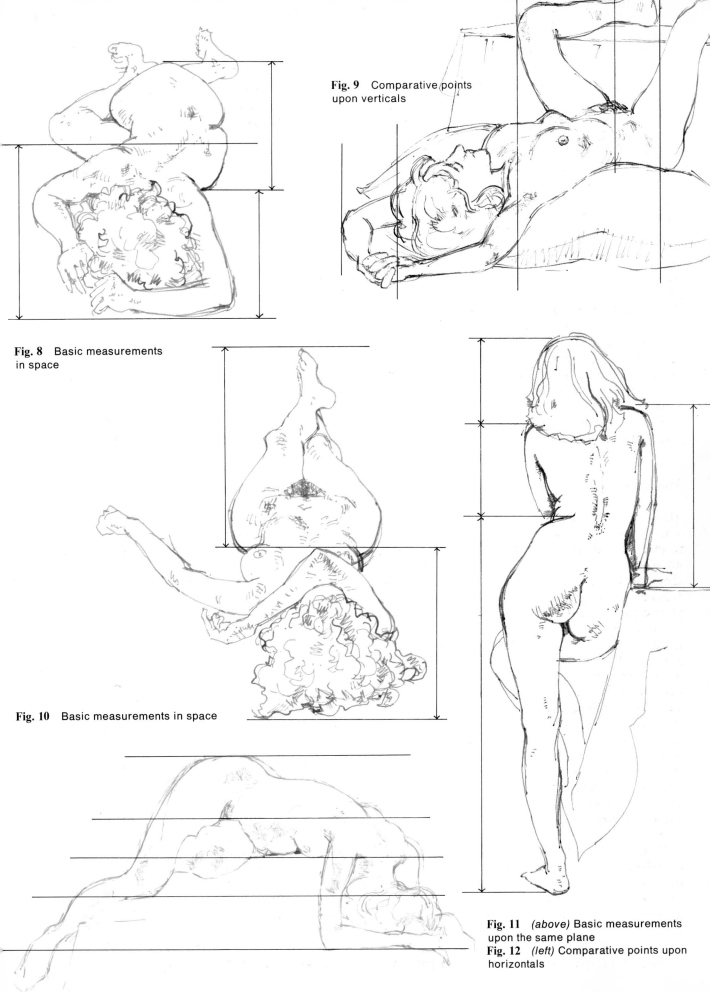

Fig. 9 Comparative points upon verticals

Fig. 8 Basic measurements in space

Fig. 10 Basic measurements in space

Fig. 11 *(above)* Basic measurements upon the same plane
Fig. 12 *(left)* Comparative points upon horizontals

BALANCE, SHAPE AND FORM

Fig. 13
Drawing in ink

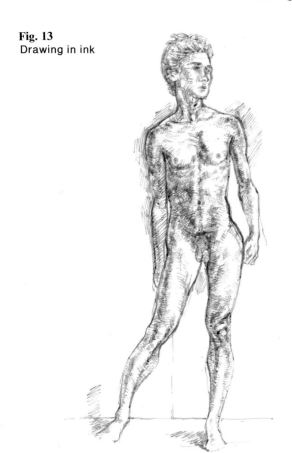

Fig. 14
Drawing in
coloured pencil

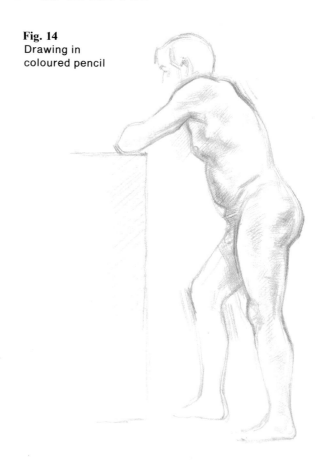

Having discussed the sort of things to be borne in mind when beginning a drawing, let us now consider some of the elements involved in a drawing once under way.

One of the first aspects that should be looked at is the shape of your model. Does she resemble the model in **fig. 15** or **fig. 17**? This could very easily affect the approach you make to the subject. It may seem a fairly obvious consideration, especially when the two examples are as extreme as they are in these cases, but there have been times when I have looked at a selection of drawings made by students in a life room and it was quite possible to believe they were all drawing a different model. To achieve the character of a person's shape is not as straightforward as one might think and cannot always be managed simply by making a number of measurements.

Form is a part of drawing that can be tackled in a variety of ways, depending upon either your approach or the character of the model. In **fig. 13** I found the structure of the model's body, being thin and without superficial fat, very suitable for making a more intricate and carefully studied drawing about precise

changes of plane and tensions from one part of the body to another. This contrasts sharply with **fig. 17** where the form is voluminous and to have worked into the drawing to the same degree would almost certainly have lost the rotund quality of the model.

Fig. 14 shows a fairly solidly built model without the generous curves of **fig. 17** but at the same time lacking the sinews and general thinness of **fig. 13**. In this drawing I found it rewarding to say something about the form contained between fairly strong contours. The fact that the pose was in profile was useful to show the grouping of the various parts of the contour and how they connected through to the other side of the body, in particular the area between the shoulder blade and chest, the stomach and back, and the top leg and buttock.

Balance is of the utmost importance in many poses, especially standing ones. **Figs. 14, 15 and 16** show a variety of ways in which balance can affect a drawing. In **fig. 15** the drawing explains itself well enough without any obvious additional supports. The angles across the breast and hips show that the weight of the

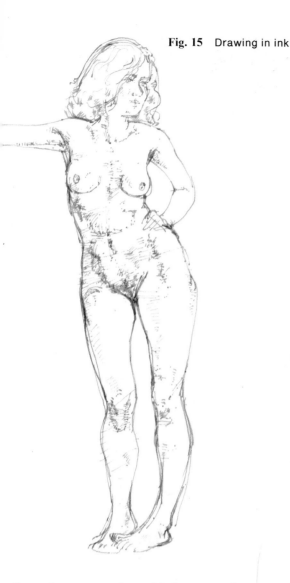

Fig. 15 Drawing in ink

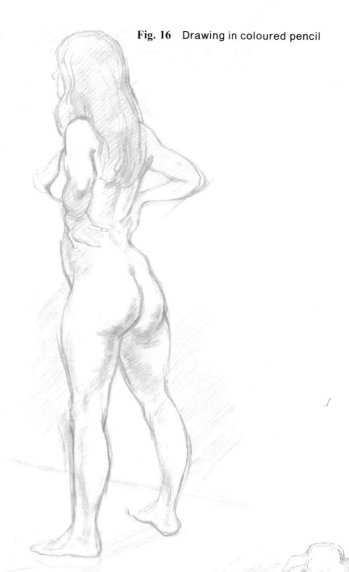

Fig. 16 Drawing in coloured pencil

figure is supported outside its own sphere. Notice, too, the central axis between the pit of the neck and the pubic arch and the angle it makes. If the figure were supporting its own weight the mass of the torso would have to be directly over the weight-bearing leg. Notice the distance and perspective between the feet in **fig. 16** and how important it is to the stance that they should be included. Unless the feet are drawn in a standing pose the drawing will never balance properly.

Exercise Pose your model in a standing position with no support and make a drawing. Then pose the model leaning against a wall or supporting the weight in some way and observe the differences between the two. Remember to watch the centre line from the pit of the neck to the pubic arch or to follow the spine at the back to show the central axis. The angle through the nipples and pelvis will give firm indications of the weight distribution.

If possible, try to make some drawings of two very differently shaped models and make a note of how you find yourself treating each subject.

Fig. 17
Drawing in pencil

TONAL DRAWING

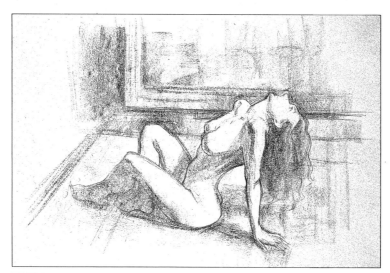

Fig. 18 First stage: drawing in black conté chalk

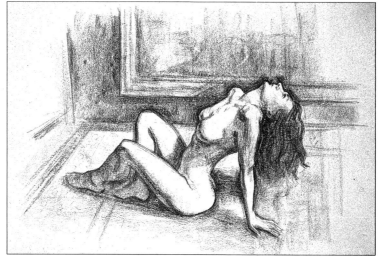

Fig. 19 Second stage

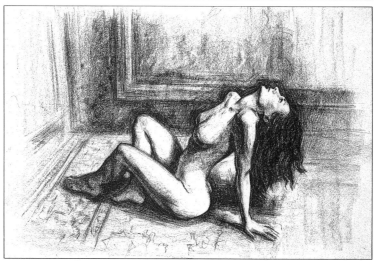

Fig. 20 Finished stage

Tonal drawing uses mass, i.e. shading, rather than just line. Before attempting any sort of tonal drawing it is important to select a light source that is suitable. On the whole, consistency of light is the best. Light that comes from one source only is particularly good because it gives clearly defined shadows. **Fig. 21** shows a figure standing in light from one source. Notice how the tone of the background, relative to whatever part of the figure it is seen against, has been used. This gives a value to the highlighted parts of the figure. Even though a background may be uniform in tone and surface, as soon as an object is placed in front of it the fall of light upon that object will make the background appear to vary tonally.

In the case of this drawing the background was a plain dark cloth, but when the figure was placed in front of it immediately some parts of her could be seen to be darker and some lighter. Most of her left side is darker than the background, for example, because it is in full shadow. Notice also the effect of reflected light: this usually shows up the edge upon a piece of form nearest the viewer; for example, in **fig. 21**, the right buttock, both the arms and the right leg.

To gain the most from a tonal drawing it is essential to understand relative tones as I have just described. Unlike a linear drawing, which can sit on a blank sheet of paper and not need any indication of background, a tonal drawing must be seen in relation to its immediate surroundings.

Using a sheet of textured watercolour paper and a piece of black chalk, **figs. 18-20** show how I envisaged making a drawing that would adequately describe form, using only tone.

First stage I made a very loose linear statement just to plot where the masses of tone should be. Once this was established, using the side of the chalk, I covered all those areas which were receiving at least some slight shadow. It can be seen that even at this early stage a pattern of tone is emerging due to the structure of the drawing with tone.

Second stage Working on top of the first tone, strength was given to areas like the hair and parts of the background to create further a tonal pattern. Major changes of plane upon the figure have also been drawn more carefully to establish solidity. Because of the direction of the light, which was strong and from above, shadows were inevitable, but within the context of a drawing like this they can be used to great advantage to assist both with the description of the form and the tonal pattern as a whole.

Finished stage As the drawing of the figure was now well established, some further enhancement of the tonal pattern was made and the development of texture in the hair and the area surrounding the face, shoulders, chest and right leg was increased. Notice how the palest tone on the right foot has remained constant, but how shadow areas around it have deepened. This illustrates how tones can be described relative to each other and to the whole. If little patches of tone of varying strength, instead of broad areas, had been put in from the beginning, the result might well have been disjointed.

Exercise Pose your model in a strong, consistent light source for three hours. Make a drawing which from the outset describes the subject with tone. Try not just to draw an outline and then fill it in; use the tone to construct the drawing. At the beginning put a light tone over every area that is not receiving direct light, then work systematically into that tone, darkening it where necessary. Pay attention to the tonal pattern and contrasts between light and dark.

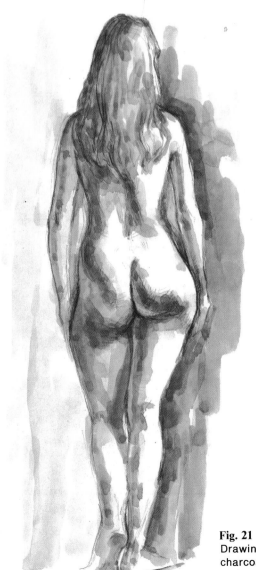

Fig. 21
Drawing in
charcoal, pencil
and wash

LINEAR DRAWING

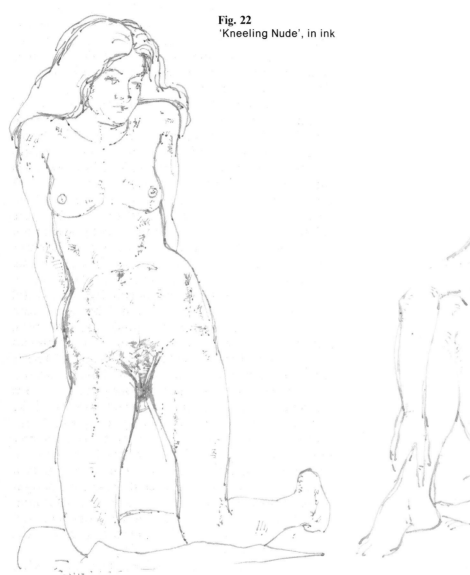

Fig. 22
'Kneeling Nude', in ink

Fig. 23
'Seated Nude', in ink

Although one does not tend to think of the execution of drawings fitting neatly into compartments, when learning to draw it can be advantageous to break down the various methods of drawing in order to understand a specific process. When looking at drawings in museums, galleries or art books it is often possible to identify a particular approach. For instance, artists like Klimt and Schiele are well known for their linear drawings and Rembrandt for his rich and sombre shadows. In this section I would like to investigate linear drawing.

First, what exactly is meant by linear drawing? Quite simply, stating the case in line and not using tone or shadow. This does not mean, however, that the drawing should have nothing but a single line, like a tracing. On the contrary, it is still possible to make a drawing that indicates sufficient changes of plane and contains structure, yet is still within the limits of a linear drawing. As in the tonal section, where a drawing was constructed with tone, here we shall look at some drawings that deal only in linear concepts.

Breaking down the elements of drawing in this way can be very useful in strengthening the concept because the aim has been more singular. I find it a very helpful exercise to be forced into a positive frame of mind by electing to tackle a drawing in a specific way.

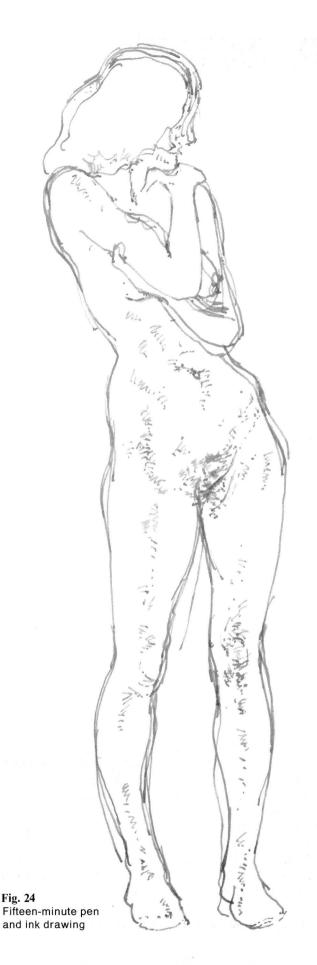

Very often the decision to treat a drawing in a particular way can be determined by the available light. For instance, if the lighting is consistent and coming from one direction, as in the standing nude in **fig. 21**, a tonal drawing would be a good idea. However, very often the light can be diffuse or multidirectional, giving no clear shadows at all or, worse, shadows everywhere. In this case a linear drawing would be a good choice because the lighting as such could be ignored, enabling one to concentrate on linear rhythms and structure.

Although almost any medium can be used, I personally find pen and ink a very satisfying combination. **Fig. 22**, 'Kneeling Nude', and **fig. 23**, 'Seated Nude', were both made in twenty minutes, using a fountain pen in an A4 sketchbook. **Fig. 24** shows a pen drawing executed in roughly fifteen minutes. You will notice that as well as line there are statements about changes of plane. These I added to give the figure solidity and in fact they were not exactly added, but used as part of the construction. However, these marks are not sufficient to interfere with the flow of the line.

Although changes of plane have been stated, which give the figure a better feeling of solidity, there is still an indication as to the direction of light. In this case it does not matter and in fact would probably have served only to distract from the main conception had shadow areas been indicated. The quality of line is fundamentally what this drawing is about. In several parts of the figure it is possible to see just a single pen line and even in the multi-line areas the origin of the line was of 'first time right' quality. Only with linear drawing, and particularly ink, can that confident 'first time right' quality really be achieved. In order to obtain this, a line must be taken without interruption for as long as possible, and even if the line is not right it can be changed by overdrawing in the same fashion. In this way the nature of line can be understood and even if many lines are made in one area they still add to the overall quality of the drawing.

As I stated earlier, the local conditions can often determine what manner of drawing is to be made. Very often poses of a short length (say, fifteen or twenty minutes) are ideal for linear drawing because the time scale does not permit a great deal of overwork. With a longer pose it is tempting to take the drawing beyond a linear statement and use tone and shadow areas.

Exercise Make several drawings in ink from poses of not more than twenty minutes. Be sure to include the whole figure. Try not to 'sketch' with the pen; take a line for as long as possible, without removing the pen from the paper. Look carefully at the model and draw confidently, paying particular attention to the quality and expressiveness of the line.

Fig. 24
Fifteen-minute pen and ink drawing

DRAWING WITH PENCIL

Fig. 25

Fig. 26 *(right)*

Fig. 27 *(far right)*

Perhaps the most standard method employed in drawing is pencil upon white cartridge paper. What we now call a lead pencil actually has no lead in it at all and consists largely of graphite. These pencils can be obtained in various grades, varying from extremely hard, which scarcely marks the paper at all, to very soft, which makes a very dark mark almost as black as charcoal. In the centre of this range is the HB pencil and the grades progress to 6B (soft) and 6H (hard) in each direction (see **fig. 3**). In most cases, for our purposes, the H range is seldom used; from HB onwards is the most usual.

Until some familiarity and basic facility in drawing is gained it is probably a good thing for a beginner to use the combination of pencil and cartridge paper as it is relatively straightforward and does not demand the special thought required by many other media. On the whole I think it is better to use a slightly softer rather than harder grade of pencil as this gives more flexibility. With a softer pencil it is possible to press lightly for a sensitive line and harder for a dark line or shading, such as in the pencil drawings illustrated in **figs. 25-27.**

Paper is obviously an important consideration, whatever the medium employed, and apart from the permanence factor the choice of paper is largely personal regarding colour and texture. In my experience the majority of people prefer a paper which has a slight grain or texture to it as this gives some 'bite' to the pencil or crayon. However, pencil on smooth paper is often used when soft or smudged edges are needed.

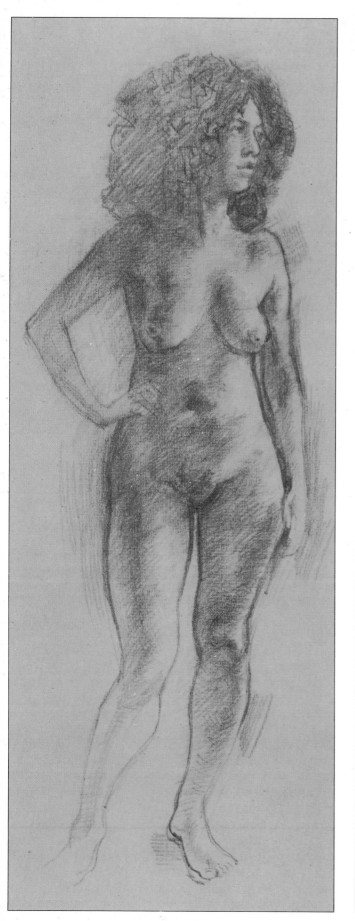

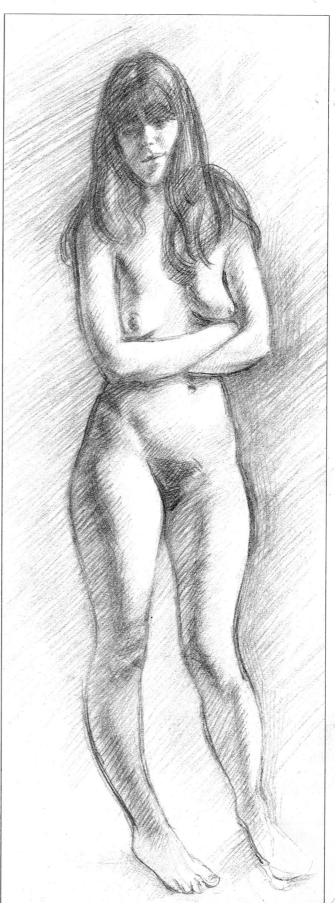

DRAWING
WITH COLOURED PENCILS

Fig. 28

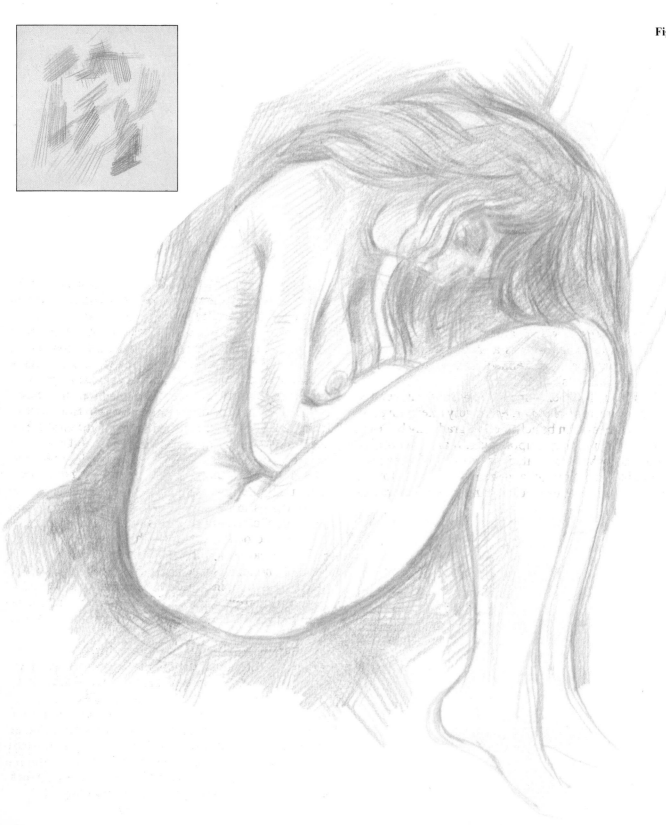

Fig. 29

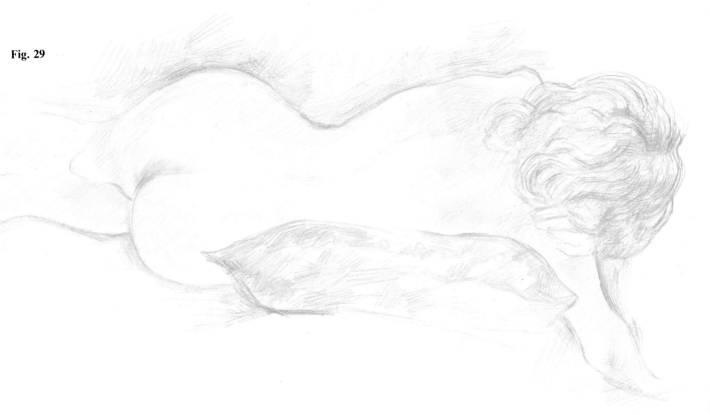

Most of the other media dealt with in this book are quite traditional in essence and have been around in some shape or form for many centuries. Wax-based coloured pencils, however, are a fairly recent development. Having started life as a medium for children, they are now in a more refined form widely used by artists and students.

These pencils are extremely flexible and can be used on almost any type of paper. Some very interesting and charming effects can be achieved by gradually building up a drawing with layer upon layer. If an effect of 'full colour' is to be aimed at, it is worth investing in a reasonable selection of a dozen or more coloured pencils. This is because their mixing potential is rather

Fig. 30

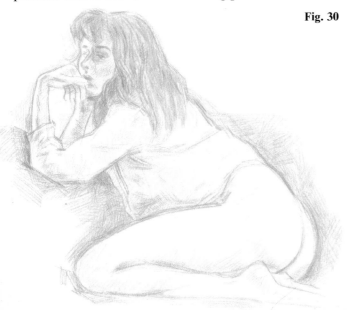

limited, unlike paint where just a few colours can be mixed into many combinations. It is therefore useful to have as wide a selection of colours as possible.

Although there cannot be said to be a right or a wrong way of using these pencils, in my experience I have found that a gradual building up using a cross-hatching type of technique can be very satisfactory.

Because of the colour, this medium has many possibilities that monochrome media do not possess. In **fig. 28** the pale, unbroken form of the model has been emphasized by sandwiching it between the crimson cushion and the orange-red hair. This contrast in colours helps the drawing a great deal. Although different colours have been used upon the figure this is more to describe the form rather than actual surface colour. For this drawing it was important not to crowd the figure with too much modelling otherwise the overall shape would have been lost.

Much the same is true of **fig. 30** where the colour of the hair has been increased even more than in **fig. 28**. The colours around the outside of the figure also play their part in making the pale, simple shape of the leg work.

Fig. 29 shows the delicate effect these pencils can achieve and also how the colour can be used in quite an inventive and almost decorative way. Rather than trying to imitate exactly the colours of the subject, as one would be inclined to do with paint, with coloured pencils it is an interesting idea to use colour to enhance the feeling of the drawing in a more personal way. In other words, you can deliberately choose colours which may not exist in the subject as such, but which work well within the context of the drawing.

Figs. 31-33 show the gradual development of an initial drawing that was made using several different coloured pencils, such as mauve for the body, brown and orange for the chair and green for the plant. I deliberately changed the colour periodically for no other reason than to keep the drawing alive. If I needed to redraw a part then using a fresh colour enabled me to see more clearly the new lines I was making.

First stage Having lightly sketched the basic form, the drawing developed with still no appreciable use of colour around the figure. Earlier I had decided the hair was not doing what I wanted it to so I asked the model to push one side back. As can be seen in this drawing this was much better because it showed the junction of neck to shoulder more clearly and also made a better design. This is one of the few situations where I would advocate the use of erasing. Having decided that an area like this is unsuitable, to erase it becomes essential. This is not the same, however, as rubbing out every 'wrong' line that is made because these are a necessary part of the growth of a drawing.

Second stage At this point more colour was added, not only around the figure to the chair, cushion and plant, but to the figure itself, further defining the changes of plane and general drawing. The image has also become denser.

Finished stage Between this and the previous stage I had second thoughts about the head and erased a part in order to redraw it. The interesting aspect about a drawing done in this manner is that it becomes difficult to know when to stop. By the time the drawing had reached this stage I felt that the figure was quite well resolved and the amount of background sufficient to make an interesting study. There were parts which I felt could have taken more work, but much of the charm of this medium lies in its sketchy, rather unfinished quality. This drawing had already become substantially more worked than any of the others and I felt that it contained enough substance for me to stop working on it.

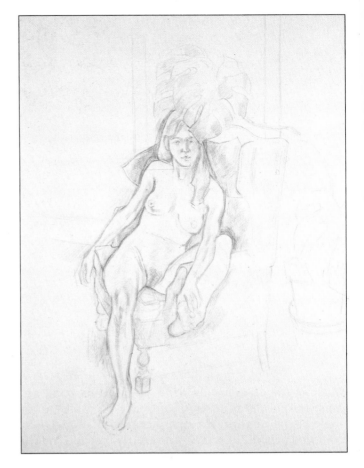

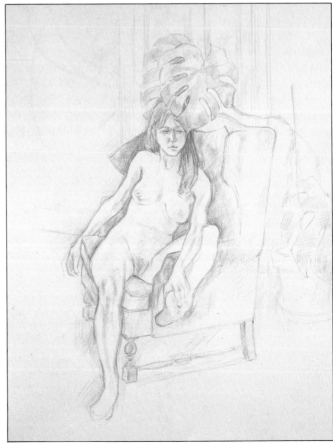

Fig. 31 *(above right)* First stage

Fig. 32 *(right)* Second stage

Fig. 33 *(opposite)* Finished stage

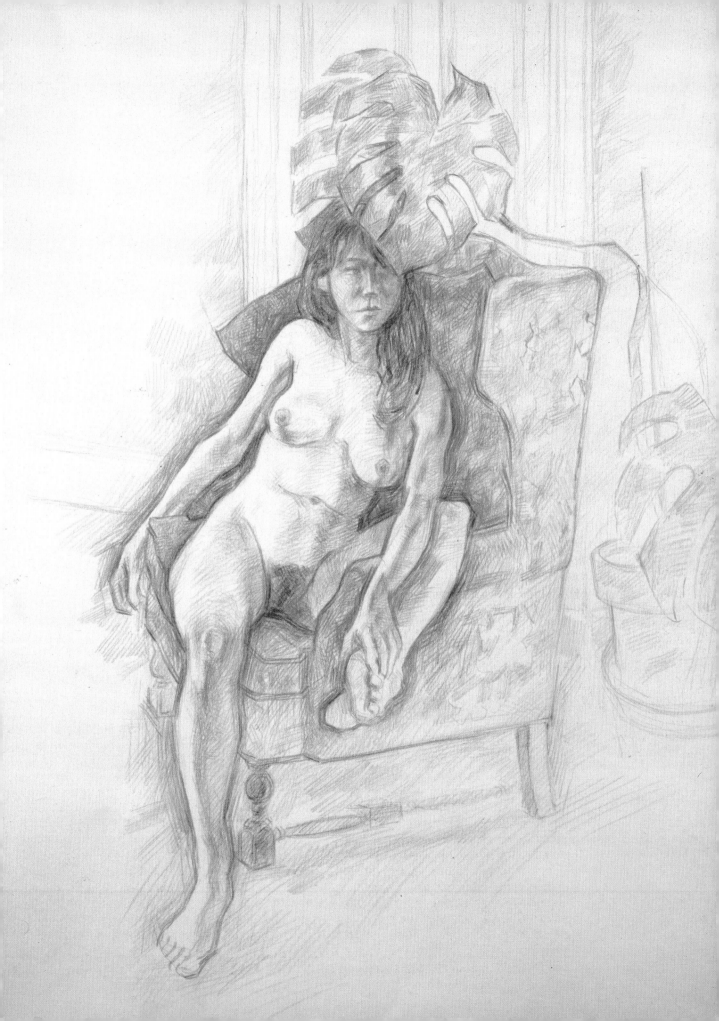

DRAWING WITH CHARCOAL

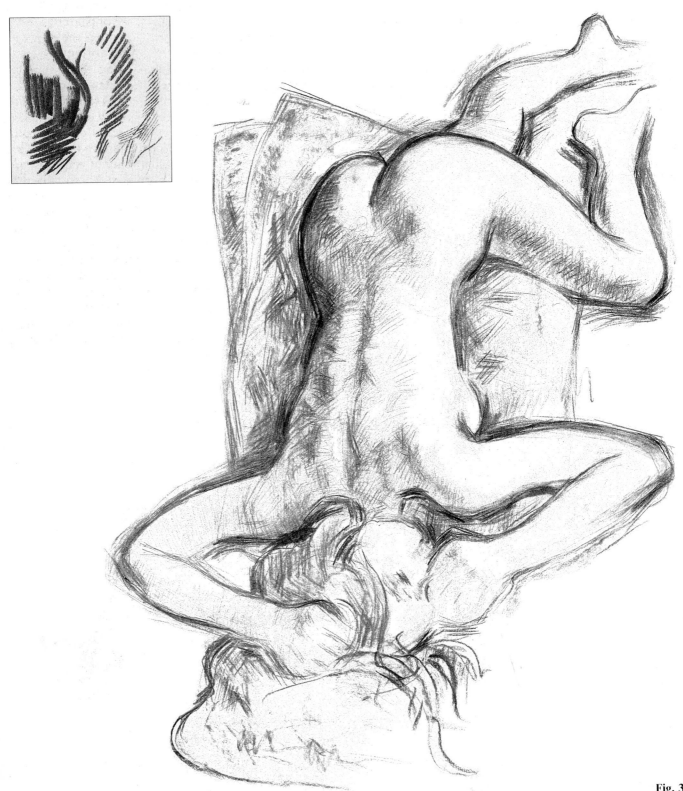

Fig. 34

One tends to associate this medium with large, black, often rather messy drawings, and certainly charcoal is ideal for more expressive, forceful drawing; but it is also excellent for smaller, more controlled work. For me, charcoal is one of the most sensitive and responsive media and I find it capable of being used in most situations.

The usual way to buy charcoal is in a box which contains a number of sticks about 6 inches long. The thickness varies from about $\frac{1}{2}$ inch to roughly the thickness of an ordinary pencil. Indeed, it is possible to obtain charcoal in the form of a pencil, which can provide a more convenient method of using it.

Because charcoal is such a versatile medium it is possible to keep a drawing on the go for a long time without it becoming overworked. Unlike many other media, charcoal, being particularly soft, lies rather like a powder on the surface of the paper, which makes it

easy to lift off with a putty rubber. It is also possible to smudge and soften edges from dark tones into light. Quite often this can be done with a stump, which is basically paper bound tightly into the shape of a thick pencil, but many artists prefer to use their fingers and this is certainly just as effective.

This was the case in **fig. 34**, a large drawing (30×20 inches) made with the thickest piece of charcoal. Here I used my fingers a great deal to soften the edges of tones. Making drawings this size is enormously satisfying in many ways, not least being the feeling of greater physical involvement. One tends to use the whole arm much more to make marks rather than just the wrist as in smaller works. When working on this scale it is very important to remember to stand back constantly in order to observe the reduced image size. This is essential otherwise all manner of proportional errors will arise. Because the image size is so large it is necessary to get far enough away to reduce the image on the retina to the equivalent of an A4 sketchbook at arm's length. Drawings of this sort are best executed standing at an easel where it is easier to step back.

In contrast to this, and using the smallest-size piece of charcoal, are **figs. 35 and 36**, both of which are roughly a quarter of the size of **fig. 34**. In order to avoid unwanted smudging of smaller drawings, a good tactic is to support the hand by pivoting upon the little finger. This serves the additional function of keeping the palm off the drawing.

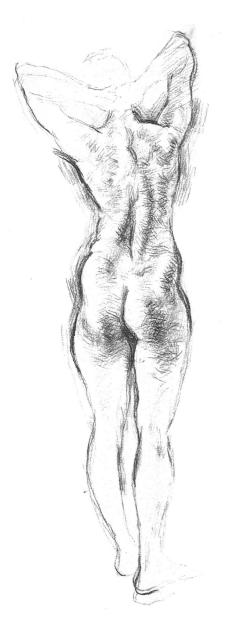

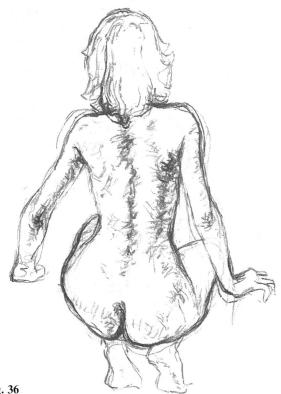

Fig. 35

Fig. 36

DRAWING WITH CHALKS

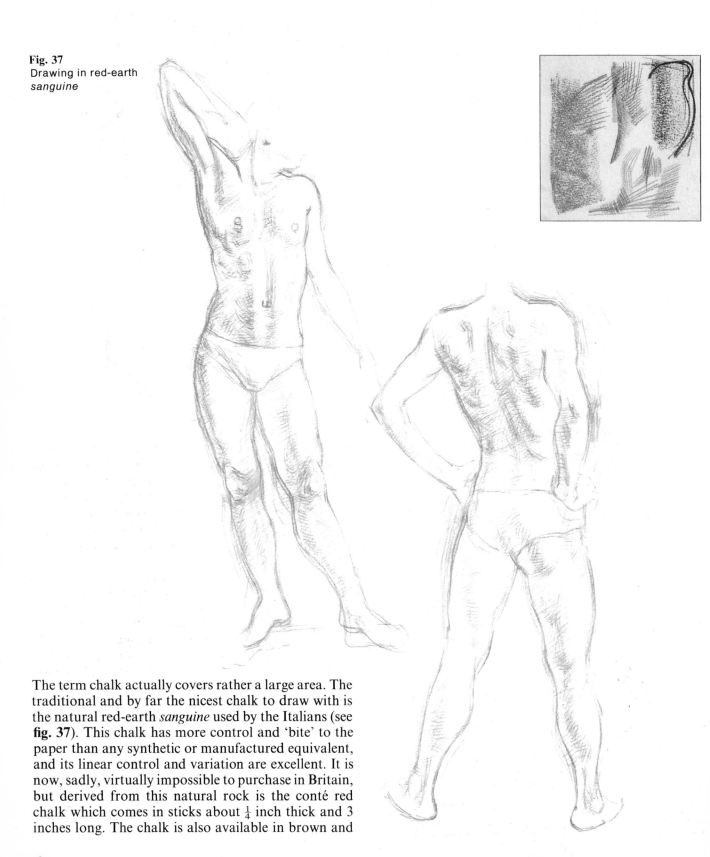

Fig. 37
Drawing in red-earth
sanguine

The term chalk actually covers rather a large area. The traditional and by far the nicest chalk to draw with is the natural red-earth *sanguine* used by the Italians (see **fig. 37**). This chalk has more control and 'bite' to the paper than any synthetic or manufactured equivalent, and its linear control and variation are excellent. It is now, sadly, virtually impossible to purchase in Britain, but derived from this natural rock is the conté red chalk which comes in sticks about ¼ inch thick and 3 inches long. The chalk is also available in brown and

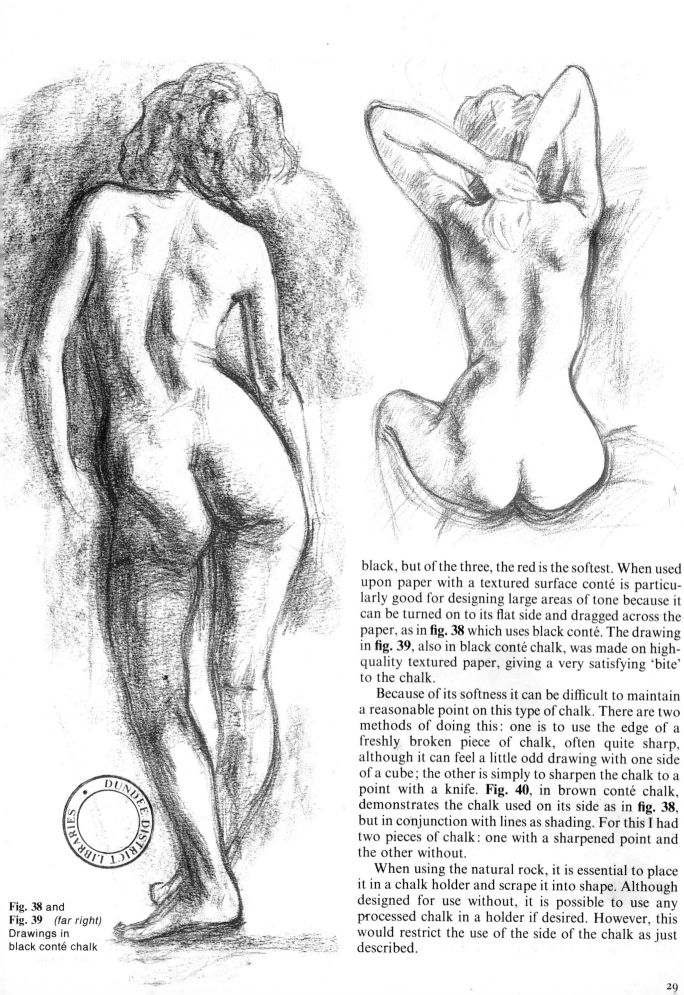

black, but of the three, the red is the softest. When used upon paper with a textured surface conté is particularly good for designing large areas of tone because it can be turned on to its flat side and dragged across the paper, as in **fig. 38** which uses black conté. The drawing in **fig. 39**, also in black conté chalk, was made on high-quality textured paper, giving a very satisfying 'bite' to the chalk.

Because of its softness it can be difficult to maintain a reasonable point on this type of chalk. There are two methods of doing this: one is to use the edge of a freshly broken piece of chalk, often quite sharp, although it can feel a little odd drawing with one side of a cube; the other is simply to sharpen the chalk to a point with a knife. **Fig. 40**, in brown conté chalk, demonstrates the chalk used on its side as in **fig. 38**, but in conjunction with lines as shading. For this I had two pieces of chalk: one with a sharpened point and the other without.

When using the natural rock, it is essential to place it in a chalk holder and scrape it into shape. Although designed for use without, it is possible to use any processed chalk in a holder if desired. However, this would restrict the use of the side of the chalk as just described.

Fig. 38 and **Fig. 39** *(far right)* Drawings in black conté chalk

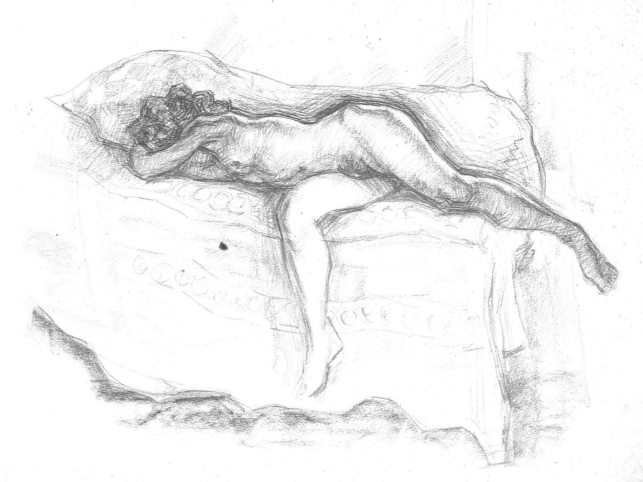

Like charcoal, it is possible to obtain chalk in a pencil form and this can be very useful for making a more detailed type of drawing where a consistent point is necessary. **Fig. 41** was drawn in blue chalk pencil, heightened with white. When used upon a toned paper it is possible to use white chalk as a highlight, but I always feel this should be done sparingly – a little can be very effective and contribute to the structure of the drawing, but too much can look as if snow has fallen!

One method of giving increased sensitivity to the chalk pencil is to dampen the paper first with a sponge and draw into the damp surface (see **fig. 42**). Any mistakes can be wiped out with the sponge, although the advantage of this technique is that they are not removed entirely and a ghost of the image remains, as a guide to making a new line. **Fig. 43** was done in exactly the same way as **fig. 42** but using the sponge deliberately to make tones. For this technique heavy-weight paper is best because thinner papers can begin to disintegrate during rubbing with the sponge.

Fig. 40 *(above)* Drawing in brown conté chalk

Fig. 41 *(left)* Drawing in blue chalk pencil

Fig. 42 *(right)* and **Fig. 43** *(far right)*
Drawings in chalk pencil on dampened surface

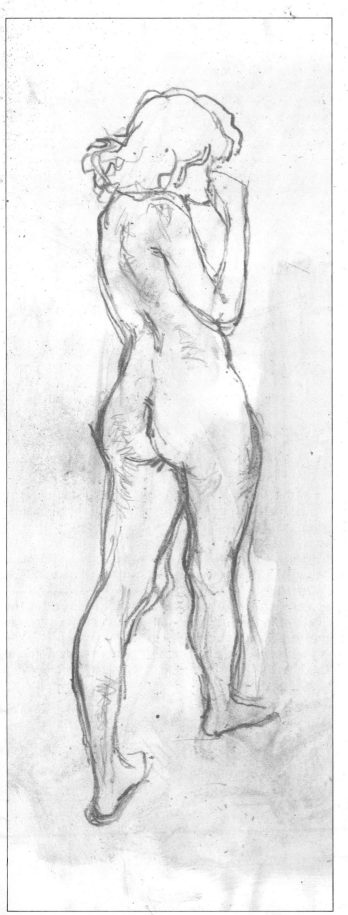
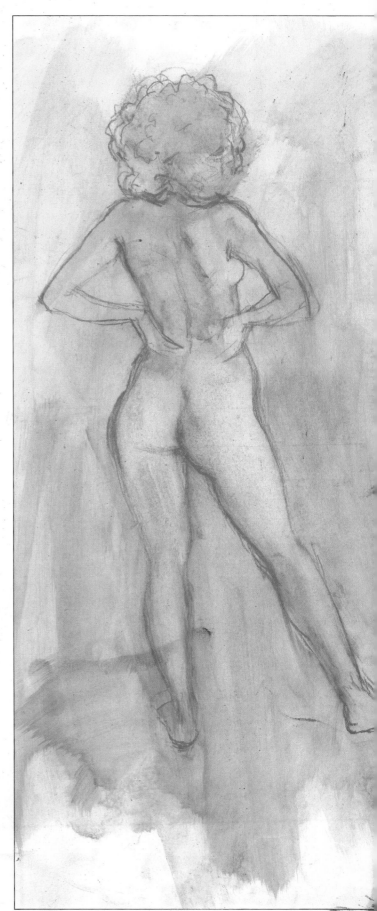

DRAWING WITH PASTELS

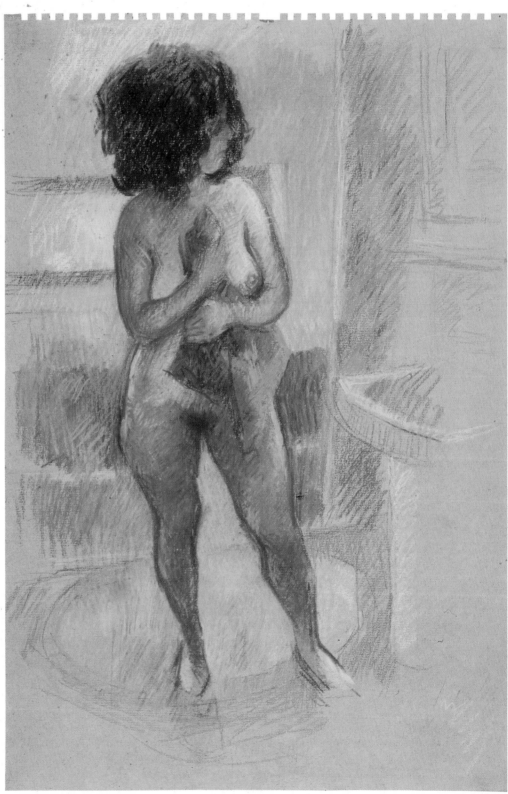

Fig. 44 *(right)*

Fig. 45 *(opposite)*

Pastels are, of course, in essence similar to chalks. Their composition is very simple – pigment with a small amount of binding medium. They have good covering power and are produced in a wide range of colours from the very darkest to lightest tints. Being fully opaque, pastels are highly suited to working on toned paper. In fact, their great charm is probably not fully realized unless used on a coloured ground.

Although a finished pastel can resemble an oil painting in density, the approach and application are very different. In the eighteenth century many portraits were made in pastels and were very polished in effect, with all edges softened by a stump or smudged with a finger. They were actually done in direct imitation of oil paintings. However, since Edgar Degas (1834–1917) we tend to think of pastels rather differently and as a medium of great individuality.

When painting one tends to use anything between half a dozen and a dozen colours but seldom more. With these colours many combinations are possible by mixing two, three or four colours together and thus achieving a mix of exactly the hue desired.

With pastels, however, the technique is to have many colours of varying tints – ready-mixed, in fact. Some pastelists work with up to two hundred different tints. Pastels can be mixed or blended either with the fingertip or with cotton wool, but there does come a time, however, when the surface of the paper becomes saturated and will not take any more pigment unless it is fixed.

There is another approach. Rather than trying to mix or blend an exact colour, as in painting, an optical effect can be achieved by laying one colour over another (see **fig. 44**). By building up in this way a little of each colour shows through, rather in the form of a mesh. This technique is much closer to actual drawing because of the nature of drawing individual lines – stroke by stroke.

Obviously there cannot be said to be a correct or incorrect way of handling pastels, or any other medium for that matter. The approach must always rest with the individual. Some experimentation is useful to discover a way of working that is in harmony with the aims and objectives of each person.

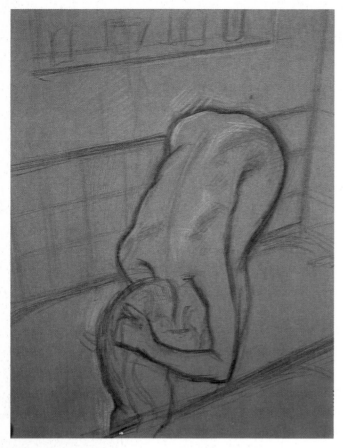

Fig. 46 First stage

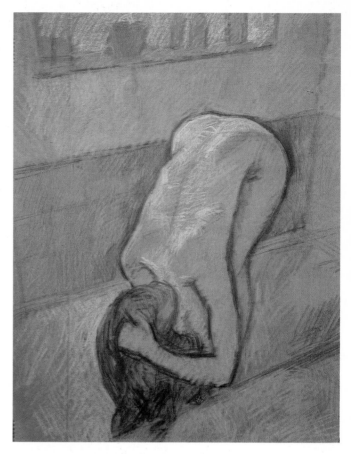

Fig. 47 *(above)* Second stage
Fig. 48 *(opposite)* Finished stage

Figs. 46-48 show the development of a drawing in pastels.

First stage Using a neutral grey sheet of Ingres paper I began the drawing with a black pastel. The composition was high on the list of priorities as well as blocking out the rough drawing of the figure. Once the figure seemed to be working on the page, I used one or two bright colours, such as Lemon Yellow tint 0 and Yellow Ochre tint 0, to indicate some high points on the back and establish the major changes of plane.

Second stage Colour was introduced here, applied fairly evenly so that no single part received too much attention. Using the stroke by stroke technique, the build-up continued, using Burnt Sienna, Red Grey, Burnt Umber, Reddish Purple and other suitable flesh tints, placing them side by side. At this stage I was aware that some of the colours, especially on the figure, were rather bright. However, as will be seen in the subsequent development, these areas were worked over with some patches left to show through.

Finished stage Apart from the addition of an extra pot on the window ledge, most of the work centred around getting the figure finally into shape. The con-

tours have now been lost completely and colour has taken over. Some of the bright orange and mauve colours on the back were tempered and worked into the general form. At no time was any mark rubbed out. If I felt a part was incorrect or needed adjusting, I did it by adding colour either over the top or placing some colour adjacent to the offending area to alter its relative effect.

At the end of this pastel the surface was just about saturated and ready for fixing. When a pastel has reached this stage it is generally advisable to fix it, especially if work is to continue, because there is a limit to how much the surface can hold before the pigment begins to fall off as powder. If a pastel is framed under glass immediately it is complete, then fixing is not necessarily essential.

There is much debate about the alteration of a finished pastel that can occur after fixing. Some alteration, sadly, is inevitable because in covering the loose particles of pigment with a liquid the optical effect of the medium is changed. However, unless framed straightaway, some fixing is needed or smudging is certain to occur. I would recommend that some experimenting with different types of fixative should be made because certain solutions act differently upon various papers.

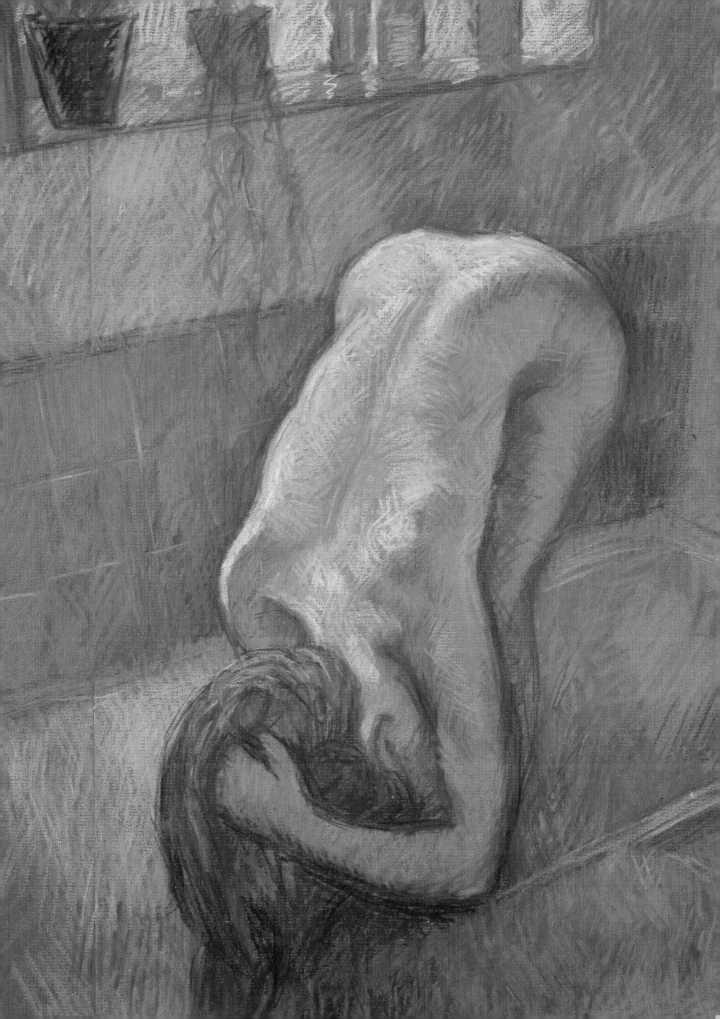

DRAWING WITH INK

For a beginner, the prospect of drawing from life with ink can be more than a little alarming because of one fact: it cannot be erased. The worry caused by potential mistakes is so great for some people that they are put off completely. But what is a mistake? As far as I am concerned, when drawing from life there is no such thing as a mistake.

If one thinks of drawing as a series of approximations, then every mark becomes valuable because it helps in gauging the next. Thus a drawing is built up by an accumulation of marks, each defining a little more the shape being drawn. As the drawing progresses each mark becomes less of an approximation and more of a positive intention. With this approach, each stage of a drawing, including the original statements, is a valuable part of the whole. Therefore there are no 'mistakes'.

With this in mind, it ought to be possible to begin a drawing in ink without any terror of the consequences. Instead, a certain freedom of mind and handling of the pen should prevail. Is it not extraordinary how inhibiting a blank sheet of paper is just before the start of a drawing? It is as if there is some hidden axe waiting to fall as soon as the first 'mistake' occurs. This fear is quite understandable and we all suffer from it to some degree. However, this is precisely where drawing in ink can greatly strengthen your all-round ability.

After a period of using pen and ink I have found that most students' objective eye sharpens up considerably. It assists in overcoming that initial fear of the first statements and helps to obtain an economy of marks based on better observation and also an understanding of the value of line.

As with any other medium, the degree of 'finish' or content will depend upon the length of the pose. For example, short poses of ten to fifteen minutes are ideal

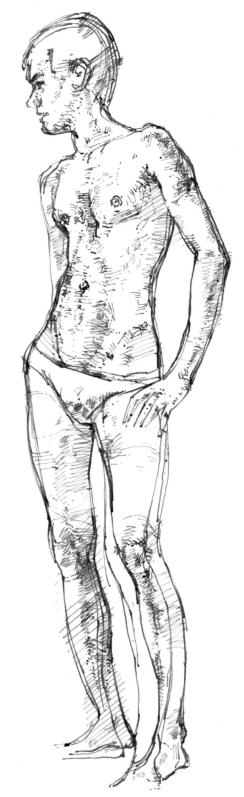

Fig. 49

36

for pen drawing to explore the linear qualities of the pose, but it is equally possible to spend three or four hours on a pen drawing as I have illustrated (**fig. 13**). Be sure, however, when making a long pen drawing, not to sketch it out in pencil first – start with the pen.

Types of pens

What sort of pen should you use? In the main, a dip pen with a bottle of ink. However, there are many different types of pen that can be used for drawing in ink (see **fig. 3**) and a few of them are mentioned here: steel nib pen with reservoir – the most common type; reed pen – made from a reed, cheap, and with a beautiful touch; quill pen – made from a goose feather which gives it a different feel from the previous two and is very nice to draw with; fountain pen – very convenient, but not to be used with india or any waterproof ink because the shellac content of the ink will cause the pen to clog up (unless, of course, it is a fountain pen made specially for indian ink); Rotring-type – hard, inflexible nib with consistency of thickness of line; biro, felt tips, etc. – useful for drawing, but the ink is impermanent, and they should be used only for sketchbook and not framed drawings.

Fig. 51

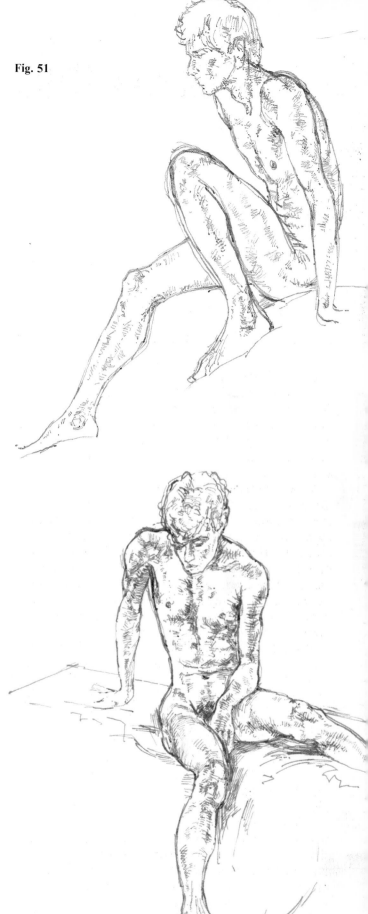

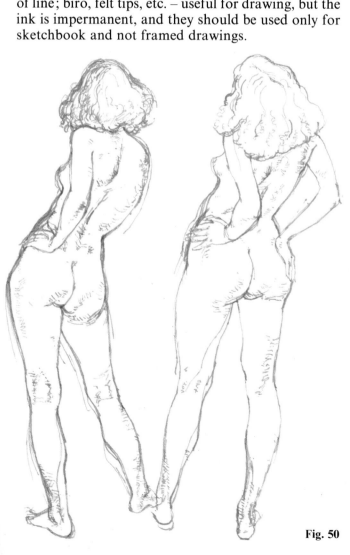

Fig. 50

Fig. 52

USING PENCIL AND WASH

Fig. 53

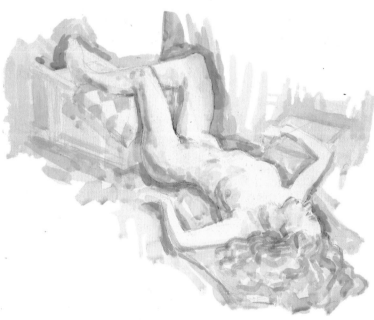

Fig. 54

The purpose of this section is really to demonstrate the possibilities of using wash. Very often wash is used in conjunction with a pen, or in the case of **fig. 55** a pencil, for sharpening up parts of the drawing. I usually prefer a pencil to a pen because I like the neutrality of its colour, and if it is used on wet paper its sensitivity is increased in the same way as chalk (see page 30).

The wash used can either be diluted ink or ordinary watercolour paint. One medium-sized, good-quality brush is all that is needed and as long as it comes to a reasonable point it will suffice for laying a broad wash as well as for more delicate work.

The drawing of the reclining nude in **fig. 53** was begun by broadly indicating with a pencil the constituent parts such as the figure, cushions and stool on its side. As soon as I felt happy with the arrangement, a pale wash was introduced to define where the main tonal areas should be, and also because I wanted the

drawing to be constructed with wash rather than by establishing a tightly drawn contour and filling it in.

When making wash drawings I find it very useful to pre-mix three stages of wash – pale, medium and dark. Having used the first wash, laying it everywhere other than direct light-receiving parts, I then move on to the second and finally the third mix. Obviously it is impossible to stick to a very strict order of application because it interferes with the creative spirit. However, by pre-mixing the washes it does at least help to simplify the subject in visual terms.

After the initial wash on the reclining nude in **fig. 53** I began with a darker mix to continue to strengthen the drawing of the figure, not just by working only on the figure but by establishing the tones around it which define more clearly certain shapes. In this instance, the right leg, the forehead and the torso can be seen to be gaining more shape and general status (**fig. 54**). One of the aspects I enjoyed most about this pose was the large amount of hair that flowed away from the body. The brush seemed to be the ideal way in which to treat this network of interesting shapes.

Finally (**fig. 55**), the image as a whole darkens and the character of the pose becomes complete. More background was also worked in to give greater value to the light areas on the figure. Some finer definitions of changes of plane have been added on the torso, but not too strongly or the simple shape of the figure would have been broken up and lost. Halfway through this drawing I took up the pencil and began to define one or two areas more sharply, like the head, right arm and left leg, but the basic character of the drawing is that of wash with broadly defined areas of shape and tone not so easily achieved with pencils or crayons.

Exercise Pose your model in a strong consistent light for three hours. Pre-mix, as described earlier, three stages of wash in separate pans – the colour is immaterial. Using only a very brief pencil sketch, begin to use the wash as soon as possible. Progress through to the final wash, strengthening with a pencil those parts of the drawing you feel are weak. Keep the application of the wash simple and try not to mix too many in-between shades.

Fig. 55

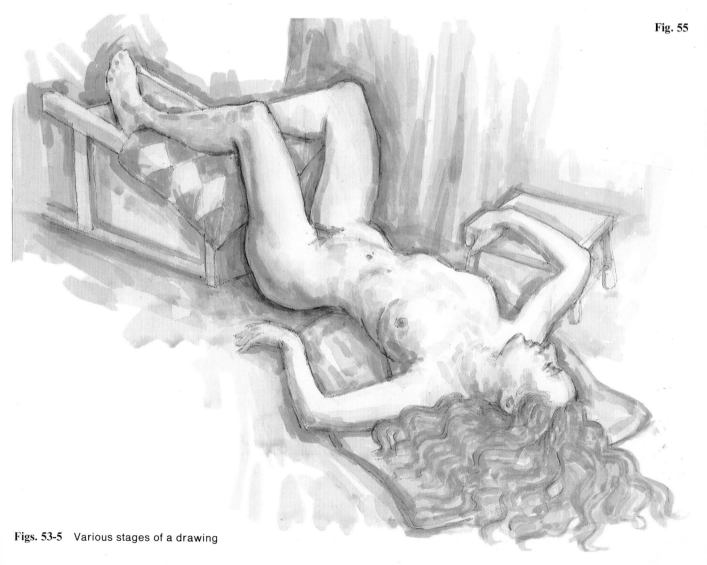

Figs. 53-5 Various stages of a drawing

USING WATERCOLOUR

One often sees the term 'watercolour drawing' when it actually refers to a painting. Traditionally, watercolours have often been referred to as drawings, most probably because of their monochromatic use in the eighteenth and nineteenth centuries.

For use in the life room or with any figurative, as opposed to landscape, subject, watercolour is an excellent medium, both convenient to use and capable of great versatility. Although more obviously a painting medium of great subtlety, watercolour can be used to deal with any situation when working from

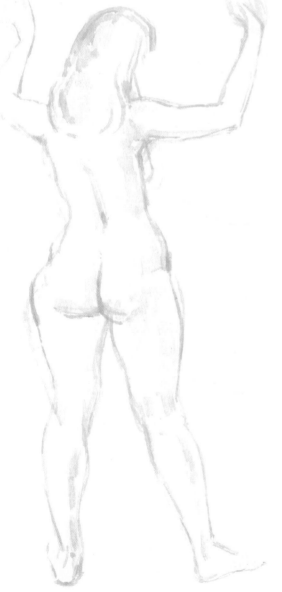

Fig. 56

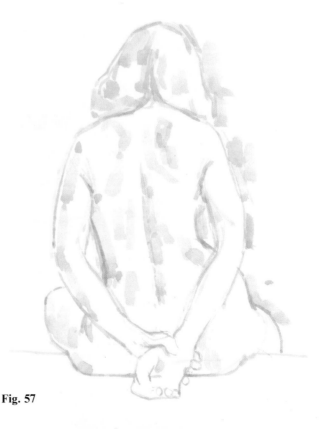

Fig. 57

the model for reasonably short periods of time.

I often use watercolour in conjunction with a pencil for sharpening up pieces of drawing at later stages. However, the great value and, indeed, joy of this medium is to use the brush rather than a pencil to begin the drawing. There is a great difference in the feel of a brush compared to pencils or crayons. To draw with a brush forces you to simplify and probably think a great deal harder about the line to be drawn. With pencils and crayons it is very easy to slip into a tentative and sketchy way of drawing, whereas a few sessions with a brush and watercolour can produce some boldly stated but sensitive drawings.

Figs. 56 and 57 were fifteen-minute poses, drawn with just a brush and some dilute colour. **Fig. 57** uses no tone as such, but a series of marks to indicate structure. The actual colour used does not really matter and in fact it is rather a good idea to vary it

within the same drawing as you correct or slightly alter lines. The colours of the lines can be varied according to the structure and even the decorative effect of the drawing. As well as depicting lines, the brush is obviously suitable for stating large shadow areas quickly and effectively, and both these operations can be carried out with one good-quality brush, preferably sable, that comes to a decent point.

Sable brushes are of course expensive, but one medium- or large-size brush will not only carry out most functions but will last a lifetime if looked after.

Watercolour boxes come in various sizes ranging from a very tiny pocket size to a large studio type as illustrated in **fig. 4**. Although it is possible to purchase the individual pans of colour and mix them on a separate palette, a box is to be recommended because it holds them all in place and has built-in mixing trays. This makes it compact and easy to use.

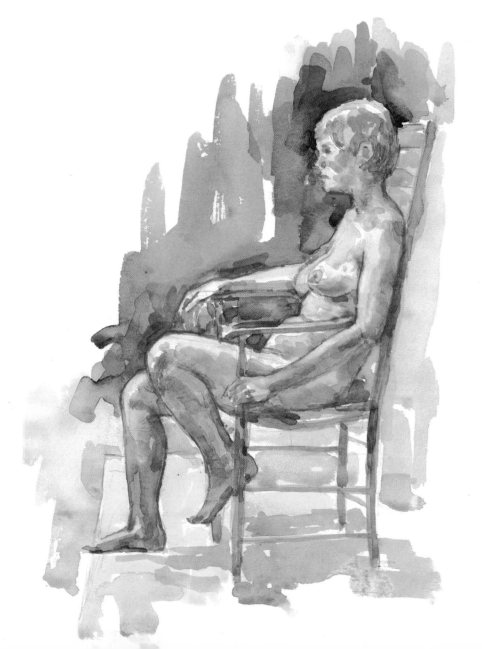

Fig. 58
Two-hour drawing

Fig. 59 and Fig. 60 *(below)* Twenty-minute drawings

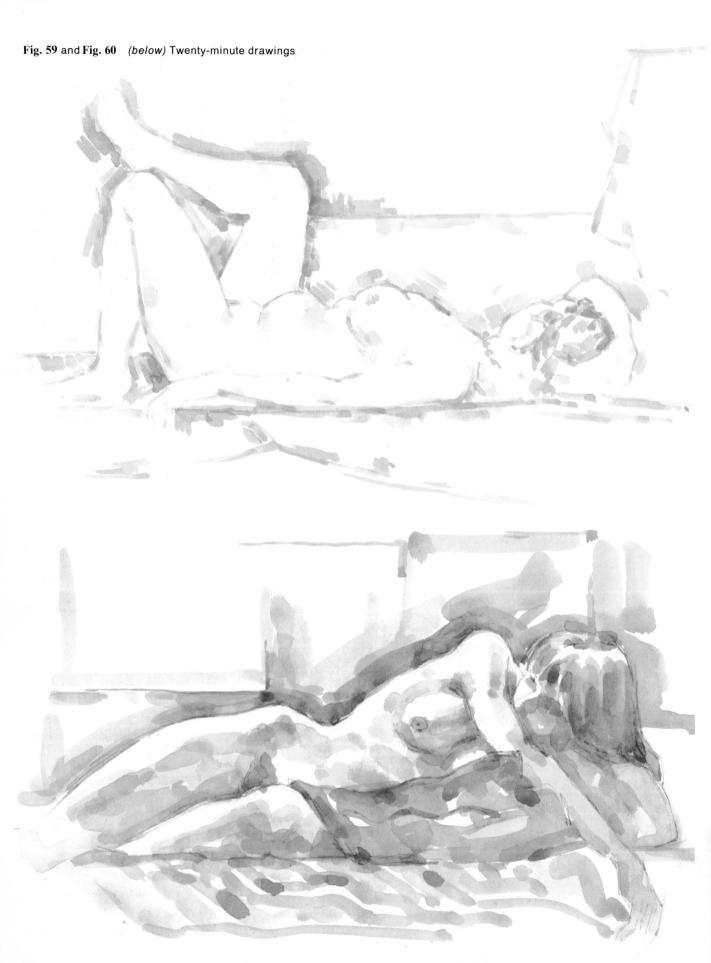

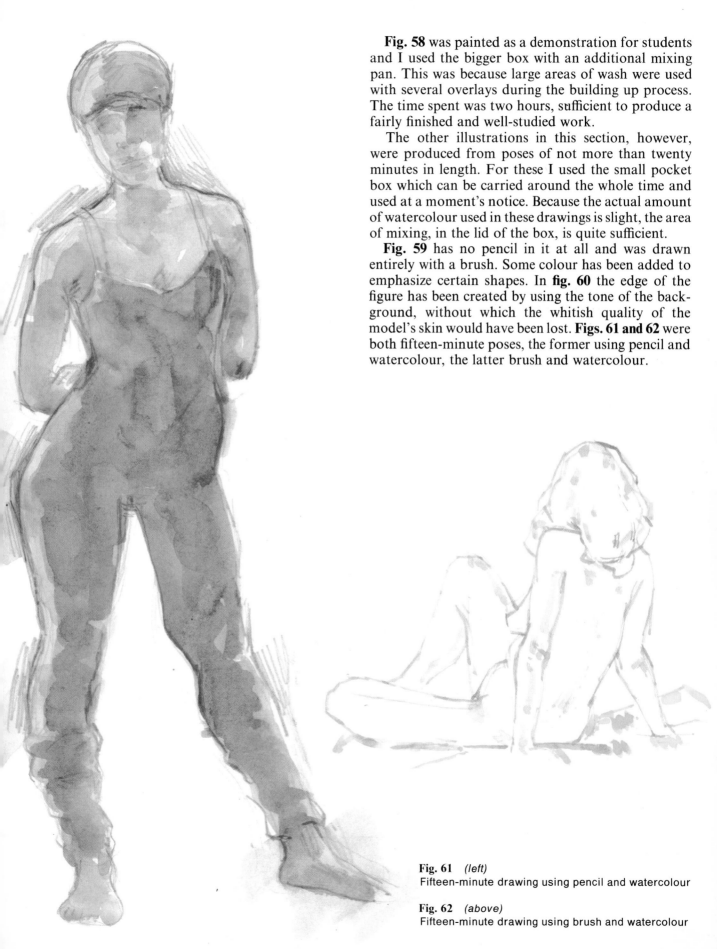

Fig. 58 was painted as a demonstration for students and I used the bigger box with an additional mixing pan. This was because large areas of wash were used with several overlays during the building up process. The time spent was two hours, sufficient to produce a fairly finished and well-studied work.

The other illustrations in this section, however, were produced from poses of not more than twenty minutes in length. For these I used the small pocket box which can be carried around the whole time and used at a moment's notice. Because the actual amount of watercolour used in these drawings is slight, the area of mixing, in the lid of the box, is quite sufficient.

Fig. 59 has no pencil in it at all and was drawn entirely with a brush. Some colour has been added to emphasize certain shapes. In **fig. 60** the edge of the figure has been created by using the tone of the background, without which the whitish quality of the model's skin would have been lost. **Figs. 61 and 62** were both fifteen-minute poses, the former using pencil and watercolour, the latter brush and watercolour.

Fig. 61 *(left)*
Fifteen-minute drawing using pencil and watercolour

Fig. 62 *(above)*
Fifteen-minute drawing using brush and watercolour

USING OIL, ACRYLIC AND GOUACHE

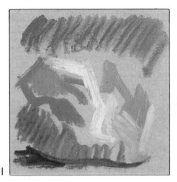

oil

acrylic *(centre)*

gouache

These three media have one thing in common: they are all opaque paints, whereas watercolour is transparent. The fundamental difference between watercolour and the other three media is the manner in which lighter colours are obtained. Watercolour is diluted with water on white paper, as explained earlier, but oil, acrylic and gouache may all be used in conjunction with white.

It could be said that these media, so obviously used for painting, do not really fit into the practice of drawing too well. This, however, would be to remove a very flexible and powerful means of expression from the artist's repertoire of media for drawing. One only has to think of the use Degas made of oil paint, thinned and used on paper for studies of dancers, to realize its effectiveness.

As anyone who has ever used a brush to draw with knows, there is a very special feeling about it which cannot be achieved by any other method. Drawing with a brush usually involves using the whole arm rather than the wrist and this can produce particularly bold and strong drawings. The tendency is to simplify more than one would do with a pencil and to group areas of contour in a stronger fashion. There is also the possibility of using a full brush to describe tone, shadow or just blocking in.

One of the distinct advantages of these opaque media is the potential use of white either in conjunction with colour or as a way of rectifying drawing. In **fig. 63** (acrylic) the white has been used to increase the silhouette quality of the legs but also to overpaint lines which were not needed. In this way the use of a light colour can be very constructive and not merely decorative.

Just how much colour should be used is a matter of personal judgement. Each artist should be guided by whatever he feels his drawing or study needs to

enhance certain aspects. For the studies of the dancer (**fig. 63**) I used very few colours because I knew that I would not be making a full painting as such but using colour in a more local and descriptive way. The colours used were black, white, red, blue and yellow – the very basic three primaries, plus a lightening and darkening agent. In **figs. 64 and 65** colour has been used to obtain flesh tones, making use of the white to produce various subtle versions of the sorts of pinks and yellows that one sees in flesh. In **fig. 65** (gouache) the colour has also been used to give the study some colour in a more decorative way, in the form of the leg warmers. Without this splash of colour the three figures might have become too large an area of unbroken flesh colours. Notice how in quite a few places the neutral grey of the card has been allowed to show through with only a light application of gouache or none at all.

At this point it might be useful to look at the nature of these media in some detail.

Oil

The usual support for oil painting is canvas or board, but it is quite feasible to use oil paint on card or even paper if it is properly treated. If several sheets of paper are prepared in advance, there should always be a surface available to work on when needed. **Fig. 64** (oil) was painted on cartridge paper, thoroughly sized with two coats of a mixture of cold water and caesin glue, and then toned down to green with acrylic paint. This makes a very acceptable non-greasy surface on which to work. Acrylic can always be used as a primer or underpainting for oil, but never the other way round.

The big disadvantage to using oil paint in a drawing studio is the amount of equipment needed; if the pose is only for an hour or so then obviously one wants to

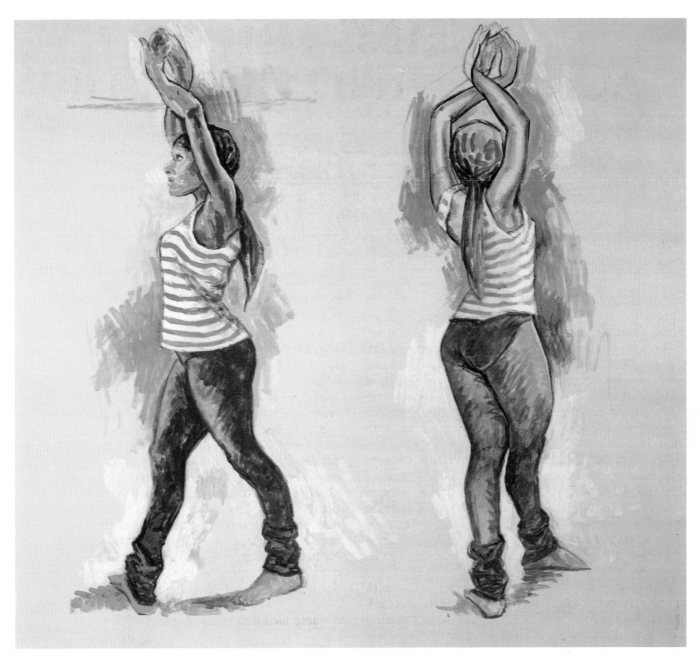

Fig. 63 Drawing in acrylic

avoid wasting time with turps and squeezing colours out of tubes. Be prepared in advance if this method is to be used.

Acrylic

Acrylic paint is a relatively recent invention and uses a synthetic resin to bind the pigment. It is water-based and is extremely flexible in use, giving thin, water-colour-like washes or thick, opaque mixes like oil paint. It dries within minutes and is thereafter totally waterproof. The advantages over oil are that the support needs no priming or sizing and acrylic can be used direct upon paper with no adverse effects. Being water-based, it is 'cleaner' than oil and there are no

transport problems as it dries immediately. One aspect to beware of, however, is that the colours, once out of the tube, skin and dry quite quickly on both palette and brushes if you are not careful.

Gouache

Although gouache has the opaque properties of the other two media, unlike oil and acrylic it is not water-proof when dry. This, of course, has an effect upon the amount of overpainting possible. The ideal support for gouache is paper or mounting card; I find the centre of window mounts a useful way of using up these leftovers. As with the other two media, gouache is particularly effective on a toned surface, giving the

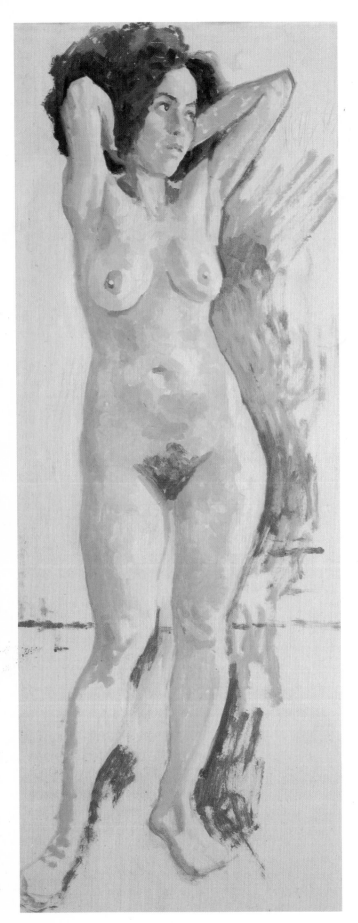

possibility of placing light and dark colours side by side. But one rather distracting feature of gouache is that it has a tendency to change to a different tone when dry, depending on how thick the paint is and how much there is already upon the surface. This can be an irritating aspect of the medium, but one which can easily be dealt with once familiarity is gained.

Should the colours dry on the palette they can be wetted and reused in the same fashion as on a water-colour pan. Gouache, like acrylic, takes only a few minutes to dry and has a very fresh and pastel-like quality.

Fig. 64 *(left)* Drawing in oil

Fig. 65 *(opposite)* Drawing in gouache

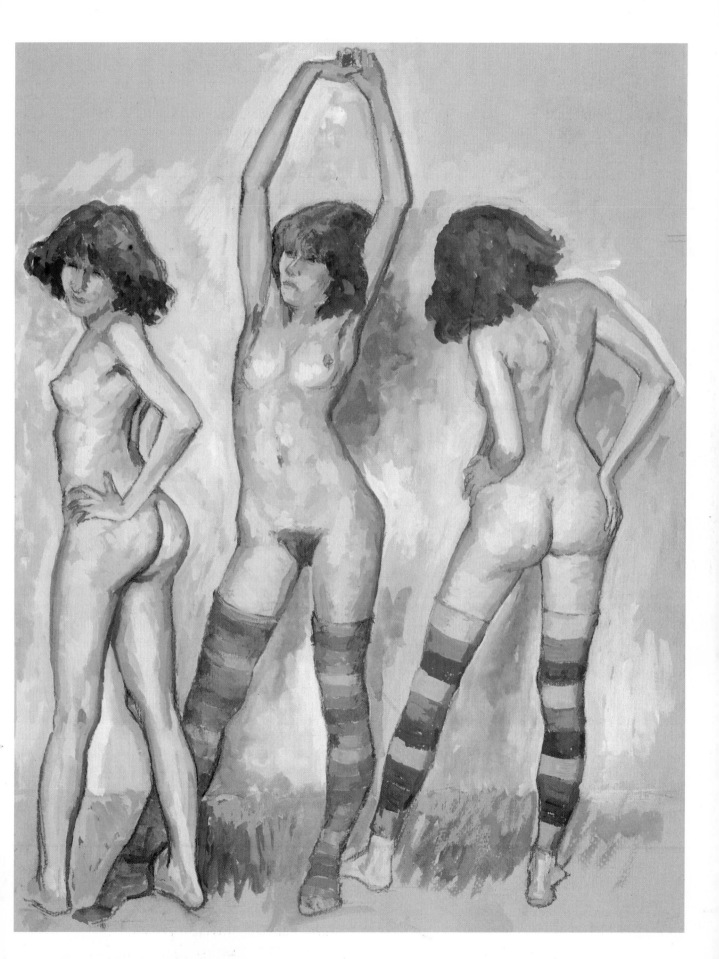

MIXED MEDIA

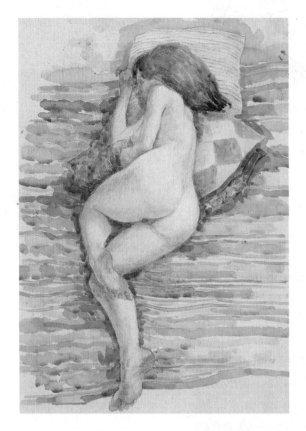

So often life drawing is taken as a serious and academic study, which of course it is, but the element of enjoyment and of experimentation should be as strong as possible. Media can play such an important part in any drawing because they can actually affect the whole quality, not so much in the obvious way, but more with regard to the thought process that takes place whilst working. It is for this reason that I feel it is important to try out many different types of media and observe the effect each one has upon both the process and the final outcome of the drawing.

It is equally important to see what happens when media are mixed. There are many reasons why one should want to mix media within one drawing: it could be that from the outset a multi-media effect is sought after; but equally, if not more plausibly, the drawing may demand the introduction of a new medium as it progresses. An example of this might be a drawing begun in red chalk which has reached a stage at which it is no longer possible to make the image any denser because of the colour. At this point it would be useful to introduce black ink to increase the density, and maybe white to highlight some areas

that have become too red. This is a very simple example, but it does illustrate that one way of keeping a drawing going is to change the media each time a passage becomes saturated or overworked.

Fig. 66 was executed in watercolour and coloured pencils. I find the combination of some types of paint and pencil very satisfactory. It is really only when media such as these are combined that texture can be explored. In **fig. 66** the coloured pencil sits very well on top of a watercolour wash in the form of a cross-hatching technique. Alternate layers of wash and crayon were used rather than two single layers. Coloured pencils are about 85 per cent waterproof so when a wash is laid over an area drawn with them the edges may soften slightly, producing a rather attractive effect. If a very sharp and well-defined series of lines is required, coloured pencils should be used last. In this drawing the white paper plays an important part in the luminosity of the body. To try to state something of the pale white, almost porcelain-like quality of the model's skin I felt the delicate overlaying of wash and coloured pencils to be suitable. To emphasize this the striped material was particularly useful.

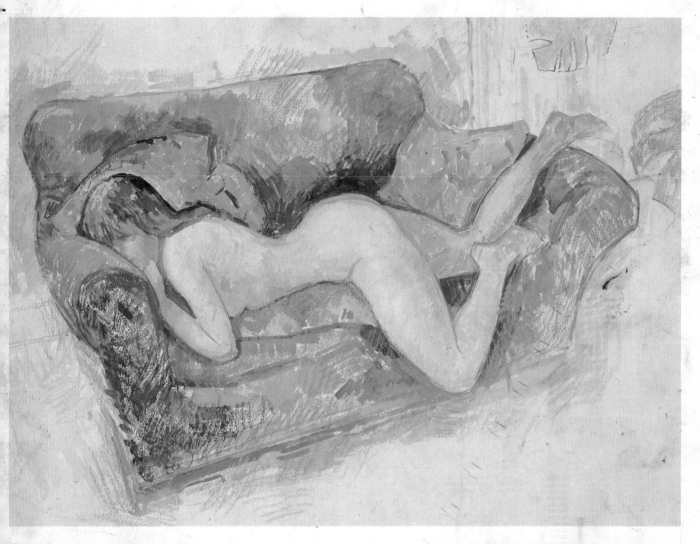

In contrast to this, **fig. 67** was put together with media of far greater covering power. In much the same way as the previous example textures were sought after by combining gouache paint and pastels. Various effects can be achieved, depending upon the stage at which the pastel is introduced. Because the pastel is very soft, by the time it has been applied to the surface it has become virtually pure pigment. This means that if a brush with water, or indeed paint, is put across this the pigment will dissolve and become like a paint. Sometimes this will need quite a lot of pushing around with the brush, depending on the type of pigment. In **fig. 67** some passages of pastel were subsequently dissolved with a brush, but on the whole I was interested in the textures possible by using pastel of a similar colour across an area of gouache.

In both these examples, colour around the figure is important to the final effect. So often insufficient attention is paid to the immediate background of a model, which is a pity because in many cases the only way to achieve something of the pale luminosity of the body is to contrast it against a richly coloured drape or piece of material. Adding background in this way

becomes particularly effective if white paper is used. As mentioned earlier, a toned ground can be very advantageous when adding light colours and it also, of course, provides an immediate background. But in the case of **fig. 67** the drawing was begun on white paper, so a background edge to the figure became rather important.

Fig. 66 *(left)*
Drawing in watercolour and coloured pencils

Fig. 67 *(above)* Drawing in gouache and pastels

ANATOMY FOR THE ARTIST

Fig. 68

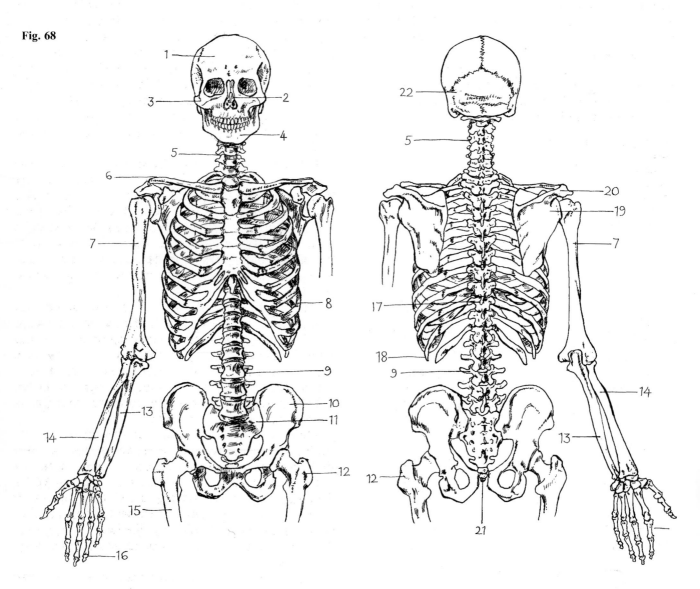

As the majority of this book is concerned with working from a nude figure it seems appropriate to include a brief survey of the anatomy of the human figure. It is a complex and involved subject and can be studied to whatever degree the artist concerned feels is necessary. Here I shall aim to give only an introduction and basic information on the bones and muscles.

Is a knowledge of anatomy essential to becoming a good figurative artist? Not necessarily, because a good draughtsman can cope with any situation; but undoubtedly it can be useful and will enhance any drawing made from life. Very often drawing problems which seem insoluble when working from a model can be reasoned out far better with a little knowledge of

Fig. 68 Bones of the head, thorax and arm
1 Frontal bone
2 Nasal bone
3 Zygomatic arch
4 Mandible
5 Cervical vertebrae (7)
6 Clavicle
7 Humerus
8 Rib cage
9 Lumbar vertebrae (5)
10 Iliac bone
11 Sacrum
12 Great trochanter of femur
13 Ulna
14 Radius
15 Femur
16 Bones of the hand
17 Dorsal vertebrae (12)
18 Floating ribs (2 pairs)
19 Scapula
20 Acromion
21 Coccyx
22 Occipital

anatomy. If an artist were asked to make a drawing of a boat, provided his objective faculties were good, he should be reasonably successful. However, if he happened to have an intimate knowledge about the construction of sailing vessels, the drawing would have a greater certainty about it, for if at any time there was confusion about technical details he, with his knowledge of boats, would probably make a drawing with more conviction.

Of course, as with all objective drawing, you should always draw what you see rather than what you know. In this way a basic knowledge of anatomy can be an invaluable aid to objective drawing.

Fig. 69 Bones of the leg and foot
 1 Femur
 2 Patella
 3 Tibia
 4 Fibula
 5 Talus
 6 Great trochanter of femur
 7 Pelvis
 8 Sacrum
 9 Navicular
10 Calcaneus
11 Cuboid
12 Bones of the foot

Fig. 69

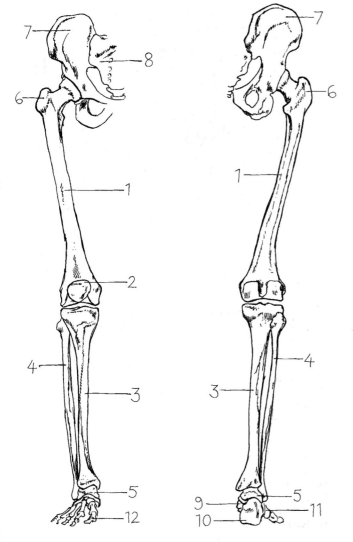

The skeleton

To begin our survey of human anatomy let us consider the skeleton (see **figs. 68 and 69**), the armature or frame upon which everything else rests. The skeleton has evolved to give maximum mobility and stability to the movements we perform. The spine forms the central part of the structure, supporting the skull and twelve pairs of ribs. These provide the cover and protection for the lungs and internal organs. When it reaches the pelvis the spine rests and divides the body weight evenly on to the legs. This creates great stability, yet allows many complex movements from the waist upwards while keeping the feet firmly planted on the ground.

The pelvis is the part of the skeleton which shows the greatest difference between the sexes. In the female it is wider and shallower, with a much greater distance between the coccyx and the pubic arch, which, of course, has its effect upon the superficial form with the characteristic wider hips in women. It is always important to study this area in standing poses and it is essential to get the correct angle across the hips.

The weight from the thorax, spread across the pelvis, is then transmitted on to the two femur bones. The femur is the longest and strongest bone in the whole body and connects to the pelvis by means of a ball and socket joint. This, compared to the similar joint at the scapula and humerus, is much deeper for greater stability, whereas the shoulder junction is shallower for increased mobility.

The junction at the knee consists of the femur resting on top of the tibia, upon which there are two shallow depressions with the corresponding condyles at the base of the femur. At the front, connected by ligaments only, is a small bone called the patella. This joint, of course, can only move backwards and forwards as far as the front line of the leg. Connected to the outside of the tibia is the fibula, which at the lower end forms the ankle.

The bones of the foot comprise seven tarsals, five metatarsals and three phalanges for each toe except the big toe, which has only two.

Returning to the upper skeleton, the shoulders are formed by the clavicle in the front and the acromion of the scapula at the back. This is the other area of the skeleton where a marked difference between the sexes occurs, male shoulders being generally wider than females'.

The arms and hands perform the most complex movements of the body, and this is due entirely to their structure. From the scapula, connected by a shallow ball and socket joint, is the humerus, which at the opposite end forms a joint for two bones, the radius and ulna. As the name implies, the radius crosses the

Fig. 70

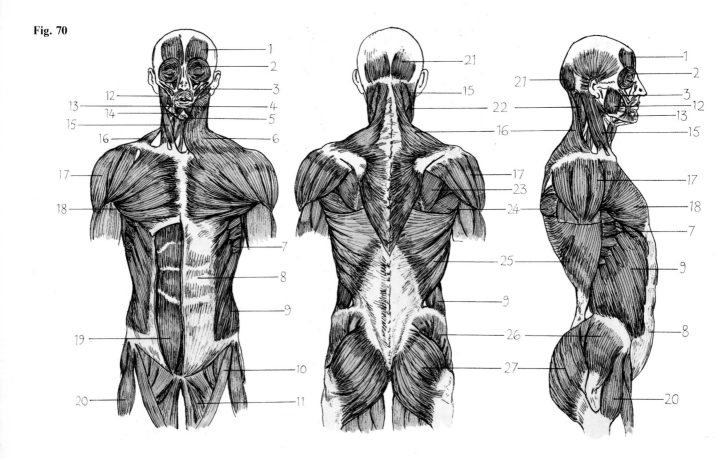

Fig. 70 Muscles of the head, neck and trunk

1 Frontalis
2 Orbicularis of the eye
3 Zygomaticus major and minor
4 Orbicularis of the mouth
5 Mentalis
6 Platysma
7 Serratus anterior
8 Aponeurosis covering the rectus abdominis
9 External oblique
10 Sartorius
11 Adductor longus
12 Masseter
13 Depressor of the angle of the mouth
14 Elevator of the chin
15 Sternomastoid
16 Trapezius
17 Deltoid
18 Pectoralis major
19 Rectus abdominis
20 Tensor fasciae latae
21 Occipitalis
22 Splenius capitis
23 Infraspinatus
24 Teres major
25 Latissimus dorsi
26 Gluteus medius
27 Gluteus maximus

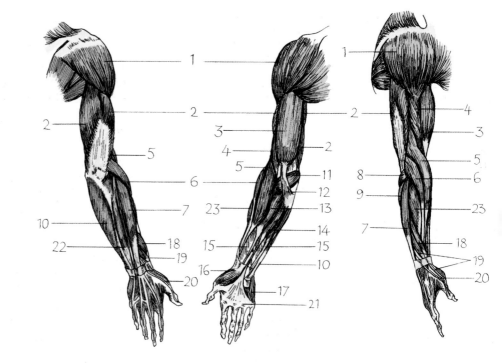

Fig. 71

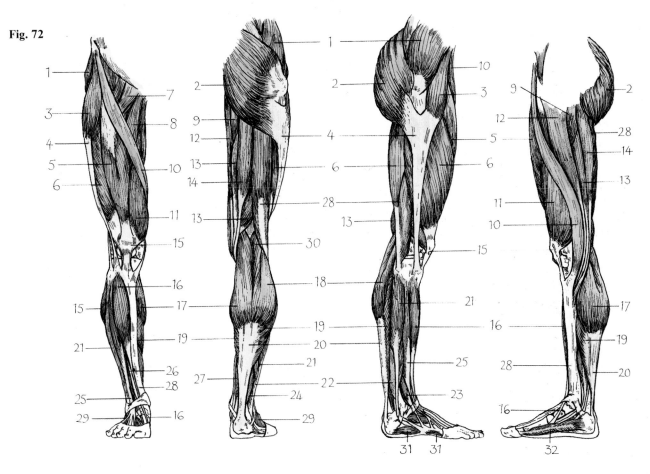

Fig. 72

Fig. 71 Muscles of the arm
1 Deltoid
2 Triceps
3 Biceps
4 Brachialis
5 Brachioradialis
6 Extensor carpi radialis longus
7 Extensor digitorum
8 Anconeus
9 Extensor carpi ulnaris
10 Flexor carpi ulnaris
11 Pronater teres
12 Tendon extension of biceps
13 Flexor carpi radialis
14 Palmaris longus
15 Flexor digitorum superficialis
16 Muscles of the thumb eminence
17 Muscles of the little finger eminence
18 Abductor pollicis longus
19 Extensor pollicis brevis (tendon of the thumb)
20 Extensor pollicis longus (tendon of the thumb)
21 Palmar fascia
22 Extensor carpi ulnaris
23 Extensor carpi radialis brevis

Fig. 72 Muscles of the leg
1 Gluteus medius
2 Gluteus maximus
3 Tensor fasciae latae
4 Ilio tibial band
5 Rectus femoris
6 Vastus lateralis
7 Pectineus
8 Adductor longus
9 Adductor magnus
10 Sartorius
11 Vastus medialis
12 Gracilis
13 Semimembranosus
14 Semitendinosus
15 Patella
16 Tibialis anterior
17 Gastrocnemius – inner head
18 Gastrocnemius – outer head
19 Soleus
20 Achilles tendon
21 Peroneus longus
22 Peroneus brevis
23 Peroneus tertius
24 Flexor hallucis longus
25 Extensor digitorum longus
26 Extensor hallucis longus
27 Flexor digitorum longus
28 Biceps femoris
29 Extensor digitorum brevis
30 Plantaris
31 Abductor digiti minimi
32 Abductor hallucis

ulna, taking with it all the bones of the wrist and the hand.

There are many small bones which form the wrist and, like the foot, the hand comprises five bones called metacarpals and three phalanxes for each finger except the thumb, which has two.

Muscles

Within this survey of the anatomy of the human body there is not room to discuss each muscle and its movements at length. However, it would be useful to mention the main groups (see **figs. 70-72**) and their functions as they affect us as draughtsmen.

What can actually be seen on the surface of a body, of course, is often rather limited and depends on whether the individual has an athletic form or is overweight. In all cases the muscular form never appears on the surface exactly as it really is. Even in the thinnest people there is a layer of fatty tissue, known as the panniculus adiposus, covering the entire body. In addition, muscles combine to work in groups so that on the surface, and especially by the time they have been covered by skin and fat, it is not always possible to trace the effect of an individual muscle. However, what is of great value and assistance to an artist is a knowledge of the underlying structure of a figure, which will help him to draw with more understanding.

There are roughly two types of muscle in the body: those which are long and small in width but often thick, occurring in the arms and legs; and wide sheet-like muscles which are found in the torso. Joining the head to the shoulders is a very important muscle called the sternomastoid, and this is always visible. It connects just behind the ear and runs diagonally to the clavicle (collar bone) to form the pit of the neck. At the back, the upper part of the trapezius connects to the rear of the cranium.

The muscles of the torso are more like cladding and provide protection for the important internal organs. At the front of the torso is a large muscle which connects the rib cage to the pelvis and is used in such movements as pulling the torso towards the legs as in the 'sit up' exercise. This is called the rectus abdominis and can always be seen to good effect on the surface despite the fact that it often carries some fat.

To the side of the torso the two main muscles are the external oblique and serratus anterior. The serratus connects to the scapula and assists in certain arm movements and is sometimes called the fencer's muscle.

At the back, running from the cervical vertebrae connecting to the dorsal and lumbar vertebrae, is a group of deep-lying muscles called erector spinae, which give the back its characteristic 'furrow' in the centre (see **fig. 73**). Lying over this group are the superficial muscles of the back, latissimus dorsi and trapezius. Both these muscles are broad, thin and cover large areas. The latissimus dorsi muscle covers virtually the whole back and comes round to the front to form the armpit along with pectoralis major, the muscle of the chest.

Fig. 73 Deep muscles of the back
1 Splenius capitis
2 Levator scapulae
3 Rhomboideus
4 Erector spinae
5 Serratus posterior

Fig. 74 Muscles of the arm
1 Deltoid
2 Triceps
3 Biceps
4 Extensor digitorum
5 Extensor carpi radialis longus
6 Ulna
7 Radius
8 Extensor carpi ulnaris

Fig. 75 Muscles of the leg
1 Tensor fasciae latae
2 Biceps femoris
3 Soleus
4 Peroneus longus
5 Tibialis anterior
6 Vastus lateralis
7 Achilles tendon
8 Gastrocnemius

Fig. 73

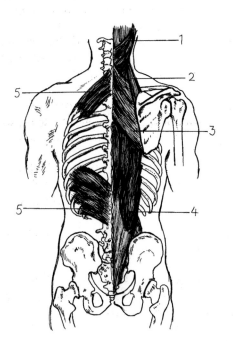

Fig. 74

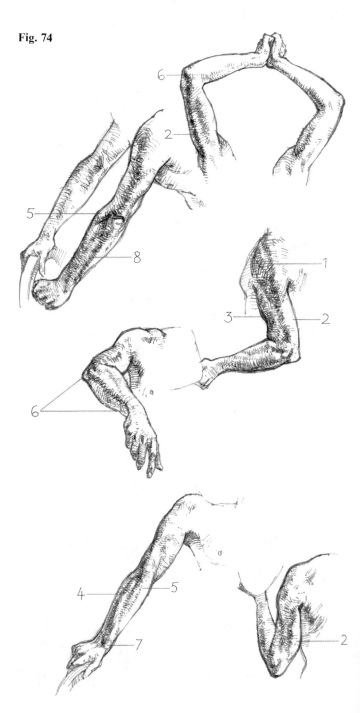

To form the connection to the arm the other important muscle in this area is the deltoid, so called because of its resemblance to the Greek letter Δ (delta). This is a powerful muscle which governs most of the whole-arm movements. The muscles which clad the humerus bone are few, but strong. The main two are the biceps and triceps, which both connect to the scapula and then to the radius and ulna respectively. These muscles are responsible for many of the movements of the forearm.

The character of the muscles of the lower arm is rather different. Here there are many long, thin muscles which connect by tendons to the fingers and thumb. The characteristic shape of the forearm is achieved because at the fleshy end of the muscles they combine to produce a bulky shape before tapering into thin tendons at the wrist. Of this group of muscles there are two which are rather more powerful than the others and which connect to the humerus, the forearm being lifted by their crane-like action. These are the brachioradialis and extensor carpi radialis longus.

The muscles of the leg resemble those of the arm to some degree. In the upper portion they are thicker and stronger for moving the entire limb, and below the knee they are thinner and result in numerous tendons which connect to and move the toes. At the back and at the top the powerful gluteus maximus forms the main muscle of the buttock and is used for running and leaping. This area, more than any other, is prone to accumulating fat and the actual muscles can really only be seen properly on an athletic person.

Connecting to the lower part of the pelvis and running the whole length of the femur is a group of muscles which form the 'hamstrings' as they part over the calf. This is an area of common tendon where several muscles join at the same point. At the front upper portion the sartorius runs from the outer edge of the pelvis diagonally across the leg to join the hamstring, and this muscle, although not always visible in its entirety, forms the basic character of the upper leg. It is very important to artists, for its effect on the overall shape of the upper leg is always apparent. Another area of common tendon is the joining of the gluteus maximus, gluteus medius and tensor fasciae latae, to form the ilio tibial band.

The area known as the calf consists of a muscle called the gastrocnemius which is divided into two portions. These connect to the femur and in conjunction with the hamstrings, which connect below the knee to the tibia and fibula, form a powerful junction which operates the whole of the lower leg. At the opposite end the gastrocnemius becomes a tendon which, as it approaches the foot, forms the familiar Achilles tendon. This attaches to the calcaneus bone and performs many of the main movements of the foot.

At the front of the lower leg the tibia bone lies just under the surface of the skin and thin fatty tissue. This is one of the few areas on the body where bone can be observed only just under the surface, the others being the collar bone (clavicle) and the iliac crest of the pelvis. To the outside of the lower leg is the peroneal group of muscles which contribute to movements of the foot.

Like the hand, the foot has very little fleshy content and comprises mainly bones and those tendons which attach to them. These tendons, as in the forearm, are the tapered ends of muscles which when grouped form the bulky area of the calf.

All muscles have a fleshy part, which expands and contracts depending on the signal from the brain. This fleshy part is then joined to a tendon, which does the pulling or pushing. In the diagrams of muscles I have coloured the fleshy parts red and the tendons yellow. The following short list explains the movements of the muscles as implied by their name:

Abduction This describes the movement away from the central axis of the body; an example of this would be lifting the arm or leg upwards and outwards.

Adduction This is the opposite of abduction and describes the movement of a limb back towards the central axis of the body or even beyond it.

Extensor A muscle which, when contracted, will extend or straighten a joint.

Flexor The opposite of extensor. When contraction occurs it brings together the two parts it connects; for example, 'flexing the biceps'.

Fig. 75

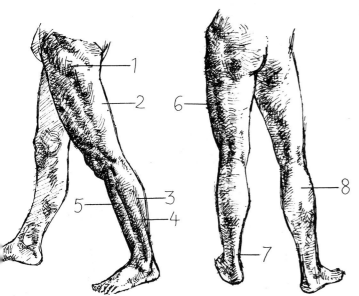

HEADS, HANDS AND FEET

Fig. 76 *(left)* Chalk drawing

Fig. 77 *(above)* Drawing in coloured pencils

These are the parts of the body which most people seem to have difficulty drawing. In theory, there is no reason why hands and feet should be any more difficult to draw than any other part of the body, although a special case could be made concerning the head in relation to portrait drawing and painting. If included as part of a general figure drawing, none of these extremities should really have too much attention paid to them. When the scale of a drawing is quite small, much simplification of the head and hands is needed in particular.

However, the extremities are of obvious interest because, in the case of the head and hands, these parts of the body contain much of the individual character of a person and therefore merit some special attention. There are, of course, no formulas for dealing with any aspect of drawing, but there are some points which one can bear in mind whilst drawing.

Fig. 76 shows a chalk drawing of an elderly man. The face has plenty of character, absorbed over a lifetime, and makes an obviously attractive subject. For such a study, placing the head in a good light and in a position that is sympathetic to your aim is important. In the case of an older person, it is not advisable to get too involved with wrinkles because it can give the effect of a screwed-up cloth. Overall shape, structure and proportion are important; observe, for instance, the distance from the top of the head to the eyebrow, the length of the nose and the length from the nose to the chin. The angles of the eyebrows, ear and moustache can also give great indication of the character of the model.

Compare this to **fig. 77** of a young girl. Generally speaking, the form is much smoother and tighter on a young person, which makes the changes of plane very subtle. Here the model's hair plays a very

Fig. 78

Fig. 80

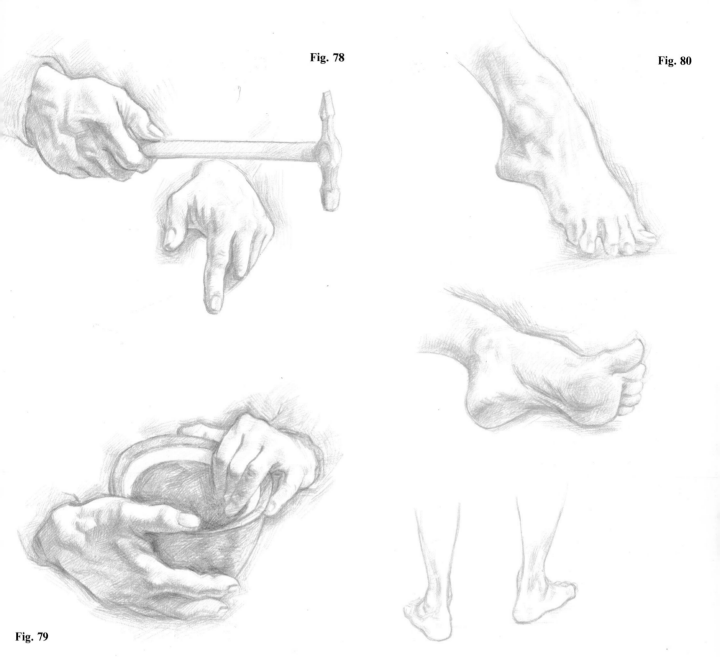

Fig. 79

important part in the shape and overall character of the head. Never forget that hair, regardless of how much there is, is a vital part of a portrait head. So often I have seen student drawings of 'faces' that appear to be no more than a mask because no consideration has been paid to the hair. When one looks at cartoons of famous people very often they are identifiable by the hairstyle alone. Sometimes, however, as in this drawing, hair can obscure vital pieces of information, such as the eyes, but this is a challenge which must be met. The hair covering the face of this girl is as important to her character as the lack of it is to the elderly gentleman.

Because hands are in constant use and perform a vast range of movements, it would seem natural, when making a detailed study, to draw hands employed in some activity. Hands differ greatly between individuals, depending upon age and occupation, so with any

comprehensive study it would be advantageous to include a cross section. **Fig. 78** shows a pair of male hands performing the ordinary task of hammering. Observe how the right hand gripping the hammer has veins and knuckles quite well defined and makes an interesting pattern of shadow areas. The hands holding the pot (**fig. 79**) make a good study because of their relationship to each other in performing the task. Notice the position of the fingers in relation to the thumb and how on the left hand the rim of the pot causes the little finger to adopt an unusual angle.

Finally, the feet illustrated in **fig. 80** show just how interesting they can be in close-up. Because there is so little flesh on them, the bone and tendons are very near to the surface, and every movement has a significant effect upon the superficial form. Notice how the ankle is higher on the inside (tibia bone) than outside (fibula bone) in the drawing of the rear view of two feet.

MOVEMENT IN DRAWING

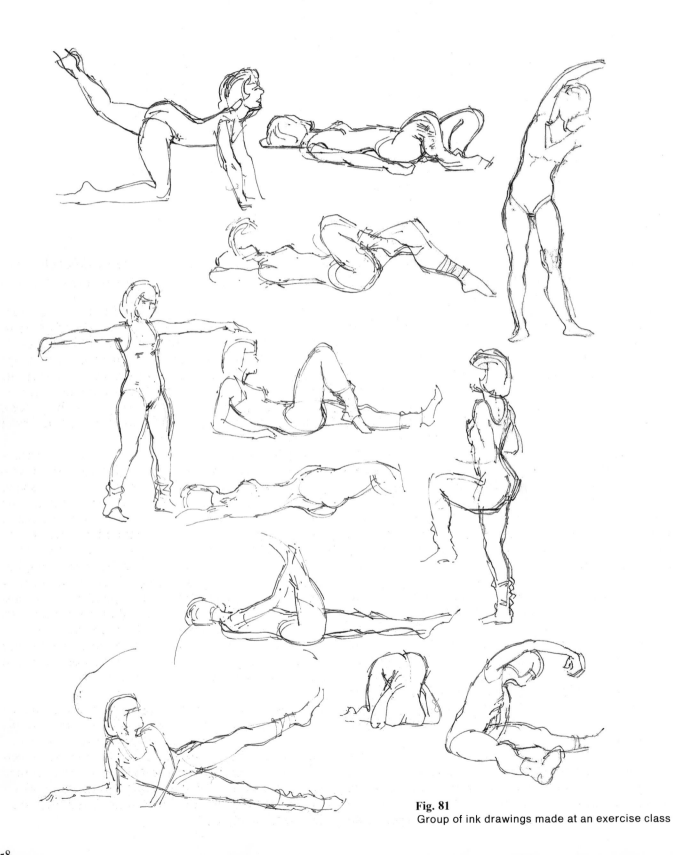

Fig. 81
Group of ink drawings made at an exercise class

Fig. 82
Drawing in charcoal

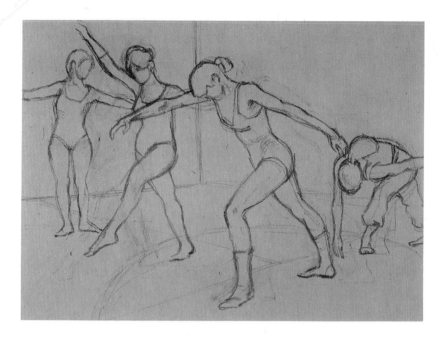

Earlier on I discussed the merits of drawing shorter-length poses as they often contain certain expressive elements that longer poses do not. To go one stage further, where the model is not posing at all, can be very exciting indeed. By this I mean drawing figures in movement.

The great value of drawing a moving figure – a dancer, for example – is that, unlike with a posed model, it is possible to follow a movement through and attempt to understand how the body works in these situations. Obviously the nature of the actual drawing has to change to suit the conditions. When drawing a posed model the usual procedure is to look repeatedly at the model before making each mark, perhaps every four or five seconds. When drawing a moving figure, however, it is more a question of studying the movement intensely and then working swiftly from the visual memory until the vision fades. Instead of trying to describe the various parts of the body accurately it is probably more useful to aim for a drawing that expresses the movement as a whole.

Fig. 81 shows a group of drawings I made at an exercise workout class; each individual drawing took between one and two minutes to do. Classes such as these and dance classes are ideal places to draw because the costumes worn are skintight and show the bodily characters well, and movements or exercises are generally repeated several times making it possible to understand in more detail their nature.

My drawings were made in ink – a fountain pen with drawing ink, which I find very convenient for this sort of an occasion. Although almost any medium can be used for this, the obvious advantage of ink is that you get an immediate and non-erasable image which is very important when the actual drawing time is measured in seconds. Large amounts of paper or an

empty sketchbook are also needed because once momentum is gained drawings can pour out at a prolific rate.

At the end of a session it is good to lay out all your drawings on to the floor, select a handful of the most successful ones and perhaps mount them on a single sheet as in **fig. 81**. Out of thirty or forty quick drawings you may find that only half a dozen work well, but this does not mean the others are failures; on the contrary, they would have been an essential part of the process without which the good half dozen would not have been possible.

Fig. 82 is a charcoal drawing made from swift notations, like the composite illustration (**fig. 81**). Using the information gained on the spot, I put this drawing together, in the studio, with the aim of taking the movement theme a stage further into composition and design. The positions of the arms and legs are vital to the flow of the movement from one figure to another.

In **figs. 83 and 84** the same idea has been used, but this time with the addition of colour in the form of gouache and pastels. Up to this point the drawings show almost a pure linear method of description, but with the introduction of colour comes tone and silhouette quality. The composition can now be further enhanced by using a near silhouette in places where the dancers are wearing black costumes.

Exercise If it is not possible to gain access to a dance class, ask your model to wear a leotard or similar outfit suitable for exercising. Then arrange for a series of movements to be repeated and make drawings which capture the whole movement. When enough drawings have been made in this fashion, use them to make a composition, taking the movement theme further as illustrated in **fig. 82**.

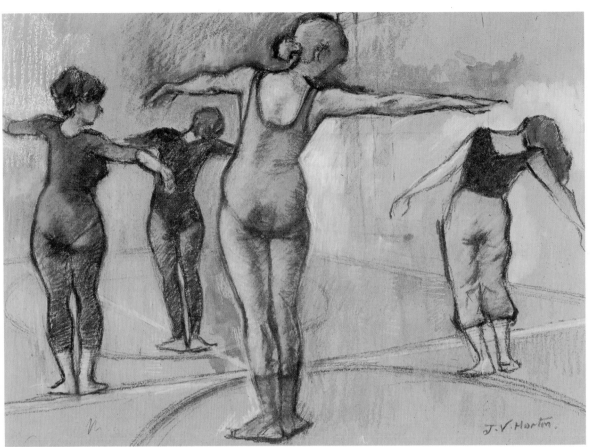

Fig. 83 *(left)*
and Fig. 84
(below)
Drawings in
charcoal,
gouache and
pastels

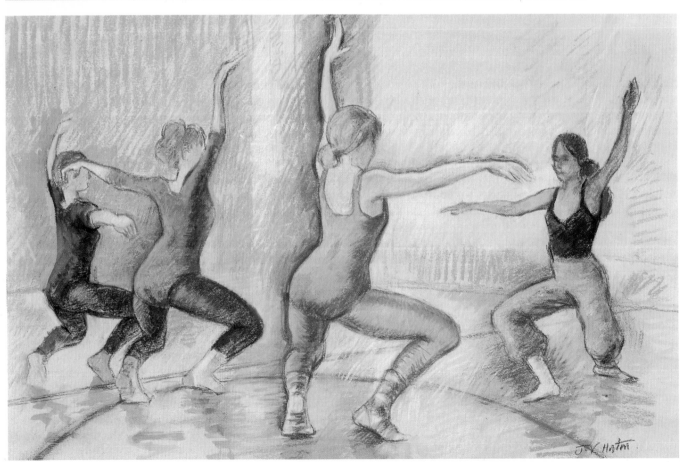

CLOTHED FIGURES

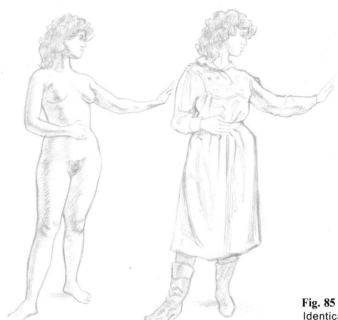

Fig. 85
Identical poses: one unclothed, one clothed

Fig. 86
Drawing in carbon pencil

Perhaps in the same way that anatomy can assist the knowledge of the superficial human form, so life drawing itself will obviously help a great deal in understanding the shape of a figure in clothes. Whatever the shape of the clothes there will always be points at which the form underneath can be observed, as the article of clothing is stressed across it. **Fig. 85** shows a figure in two identical poses: one clothed and one unclothed. The hips and shoulders are obvious points from which the clothes can be seen to hang. Notice, too, how the sleeve of the blouse behaves on the extended arm; gravity causes the material to hang so the top edge of the arm shows the form underneath quite well.

Fig. 86 is a fairly straightforward pencil drawing made in a linear way to depict the effect of folds upon a suit. Because of the position the man is standing in, some parts of his clothing display many creases whereas those areas where no significant bending takes place are relatively crease-free. A suit such as this is carefully designed and tailored to achieve a certain effect which is complementary to the body inside it. It also possesses well-thought-out proportions; for instance, the way in which the waistcoat appears to finish fairly high and overlaps the trousers, thus making the legs appear to be longer than perhaps they really are.

This contrasts rather nicely with **fig. 88**, which depicts somebody wearing fairly loose-fitting clothing.

Rather than looking for individual folds in this drawing, I sought a more overall effect about the figure as a whole. It seemed important to try to state something of the character of the model in her clothes.

Fig. 88 was made as a preliminary to a life drawing session. Very often it can be advantageous to draw your model with clothes on before beginning or even after finishing a life drawing. If it is a model you are familiar with, this can be of great benefit in getting to understand how clothes work upon a person.

Exercise Make a drawing from a pose of one and a half to two hours and then ask your model to put his or her clothes back on and take up exactly the same position. Note where the stress points come and compare your second drawing with your first.

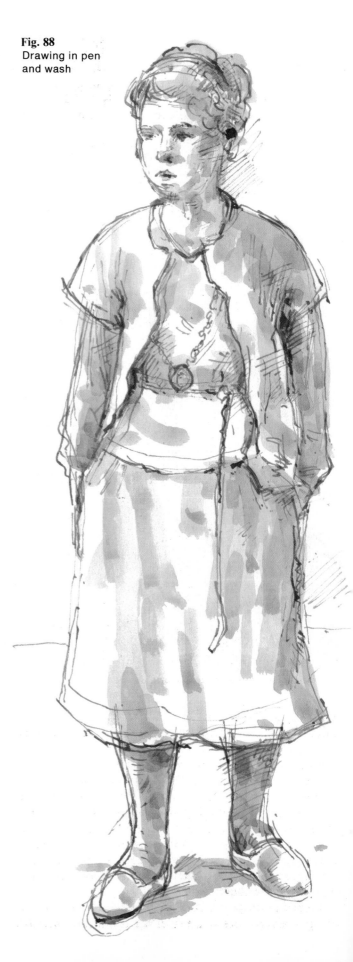

Fig. 88
Drawing in pen and wash

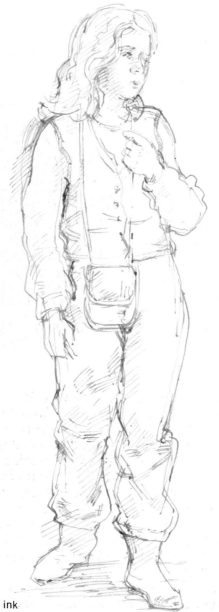

Fig. 87
Drawing in ink

FIGURES
IN AN ENVIRONMENT

Fig. 89 Drawing in watercolour and pencil

Most of this book has been concerned with studies of single figures in one form or another. When some experience has been gained with figure drawing, the obvious progression is into making a composition including several figures. These would then have to be seen in some sort of environment. In various sections of the book I have stressed the need to relate the figure to its immediate background, even if it is only a tone without any description. When figures are put into an environment, this obviously becomes essential; you will appreciate then having already done this from time to time in the life room.

Lighting is important, of course, because the source of light always has a great effect upon any interior.

Fig. 89 is one of a series of watercolour and pencil studies I did in preparation for a large oil painting. With four figures to set into a large room I felt the need to experiment with various combinations of sitting and standing poses. When making studies of this sort one becomes particularly aware of how people behave when they are sitting or standing and whether they are comfortable and relaxed or ill at ease with their immediate surroundings. The lady on the sofa seemed to be rightly posed from the beginning whereas I placed the other three differently in other studies to see the effect.

The other important factor in a study of this sort is the space that surrounds the figures and the effect it

Fig. 90 Drawing in watercolour

has upon them. Unlike life drawings where one automatically 'closes up' on the subject, here various effects can be achieved, depending upon how far away the subject is placed.

Fig. 90, in watercolour, shows a girl in a pose reminiscent of many seen in a life drawing studio. In this instance she was placed in the fairly natural surroundings of an attic bedroom, and as always the lighting is of the utmost importance. Rather than going for a particularly accurate or anatomically descriptive figure, I thought it important that the model should take her place within the scheme of the whole interior and the lighting effect. Thus the side of her nearest the window is rather well defined and the opposite side is much closer in tone to the background with less contrast.

Because of the vertical nature of the pose it is also most important to place the figure sympathetically within the rectangle. Here she relates to the other two verticals of the window area, creating an interesting division and proportional arrangement. Although the architecture of an interior may seem impossible to alter, remember that a figure is a more flexible agent and can be moved around more easily when working out compositions of this nature.